# MAKING ROOM FOR MAKING ART

A
THOUGHTFUL AND
PRACTICAL GUIDE
TO BRINGING THE
PLEASURE OF
ARTISTIC EXPRESSION
BACK INTO YOUR
LIFE

## SALLY WARNER

CHICAGO
REVIEW
PRESS

Library of Congress Cataloging-in-Publication Data

Warner, Sally.
  Making room for making art : a thoughtful and practical guide to
bringing the pleasure of artistic expression back into your life /
Sally Warner. — 1st ed.
      p.      cm.
      ISBN 1–55652–212-6 :
      1. Artists—United States—Psychology.   2. Creation (Lit
erary, artistic, etc.)   3. Artist's block.   4. Art—Technique. I. Title.
N71.W35 1994
701'. 15—dc20                                              93-40774
                                                           CIP

          Published by Chicago Review Press, Incorporated
          814 North Franklin Street, Chicago, Illinois, 60610

          Printed in the United States of America

          ISBN: 1–55652–212-6

8

*For Kit and, ever, Claire*

Cousin, show your heart,
from the same orchard
as mine.

—Dennis Finnell, from *Taking
Leave of St. Louis*[1]

# Contents

# Introduction

THIS BOOK IS intended for any artist who has lost sight of his or her most authentic art. It is meant for the "lost artist," whether that artist has been lost for one endless day or for years.

There isn't any one way to be an artist, but given the chance, we can learn from and support one another. The awareness that there are many struggles we share can help all artists persevere.

I hope that this book will help break through some of the isolation every artist faces by exploring how we as artists discover our art, how we continue to discover it, and how we keep making that art, in spite of everything. Perhaps this honest airing of both the struggles and pleasures inherent in a life in art can help the artist reader overcome personal obstacles and rethink some old attitudes—attitudes about subject matter, materials, time, work space, money, external pressures, and internal barriers. I also hope that *Making Room for Making Art* will give readers who are not artists a better understanding of what it means to be an artist today.

There are a hundred reasons to stop making art, but some people continue. That's what is interesting. The eight artists interviewed for this book are all enduring, lifelong, working artists. Their work is dissimilar, but I discovered they hold many attitudes in common. And each artist's work authentically reflects his or her life and general philosophy.

There are differences among the eight artists. A few of them live in Southern California, as I do. Two of them live near San Francisco, one lives in New Jersey, and one lives in Brooklyn. All have worked at various jobs for money, though those jobs—and the artists' attitudes toward them—have differed. Their personal lives vary. The

artists, men and women, are of different ages, and their outlooks often differ.

Throughout *Making Room for Making Art* I have interspersed my own views with those of these artists: Jerry Ross Barrish, a sculptor and filmmaker; Virginia Cartwright, a potter; Claire Henze, a photographer; Douglas McClellan, a painter, poet, and collage artist; Stephanie Rowden, who makes drawings and installations; painters Sheba Sharrow and Harrison Storms; and LaMonte Westmoreland, who concentrates on assemblage. I draw. Our backgrounds, current lives, and art are different, but there are certain characteristics many of us share. These characteristics may or may not be positive ones, but they certainly help us continue as artists.

For more information about these eight artists and about my own work, please see Chapter 9, "Meet the Artists."

Artistic momentum *can* be regained and vision sustained. If we as artists can each establish an independent structure that works, and if we can cultivate a renewed sense of kinship, of community, with fellow artists who are candid about struggling with their art, continue to work in spite of these struggles, and feel it's worth it, then each of us has a better chance to become—to remain—an enduring artist.

# Lost
# and
# Found

> **"You talk of the emptiness you feel everywhere; it is just that very thing that I feel myself."**
> **—Vincent van Gogh, from a letter to his brother, Theo van Gogh**

**W**E ARE TRICKED by a phenomenon of time: Hours and days pass slowly, but years pass quickly. A *life* passes quickly, but we always think we have plenty of time.

Too often we become so consumed with how we spend our days that we lose track of how we are spending our lives. What is important in the long run, that a person always has a balanced checkbook, eats healthy foods, and shows up on time for appointments, or that he or she is actively engaged in "real life," especially in the process of creation?

I think that most of the people who once enjoyed art classes in high school, college, or even graduate school have stopped making art by the time they have been out of school a few years. It can seem less painful to give up art altogether than merely to limp along with it. No matter that these artists were once passionate about their art or that it once felt like the most important thing in their lives; these extremely able people lose their art, and I'm certain most of them miss it.

It's easy to lose your art, to lose your way in the studio, and it can get easier as the years pass. The difficulty, the challenge, is to return to that art—to find your most authentic art and keep it. Obstacles to creativity pile up as life becomes more complex. The artist balances his or her art on an imaginary scale against the contrasting and constantly changing weights of family, financial obligation, and the whims of fortune. The artist becomes increasingly removed from a sheltered school environment where commitment to art went unquestioned. Contemporary society has plenty of questions for artists: "Are you making any money yet?" "Why do it if it's so hard

3

on you?" "What are you trying to prove?" And those are the *polite* questions.

It's easy to lose your art when your supportive community vanishes. Art legend tells us that a hundred years ago—even fifty years ago—artists banded together at bistros and bars. Those days are gone, but artists' need for community remains. Artists still need to be around other artists, and not merely at art openings where everyone must present a confident face to the world. Honest communication among artists is necessary, and it won't happen at openings.

Artists need solitude, but we also need a sense of artistic community. Recognizing our connection with other artists, past, present, and future, will help us overcome some of our isolation. Many struggling artists can't believe that others have occasional or even perpetual doubts about their work, for instance. But how could they not have doubts in a society that values contemporary art so little? It's hard for a despairing artist to realize that other artists feel alienated too at times, or even fraudulent. For too many artists, the isolation is complete, and that is insupportable. We've all heard that it's hard to stay sane in solitary confinement, but what about voluntary solitary? Doesn't that border on self-punishment?

Working alone in the studio isn't solitary confinement, but it can feel like it. Staying focused on art for a lifetime requires an extraordinary exertion of will under trying circumstances.

Some artists stay focused more easily than others. The ones who keep working may have a greater capacity for solitude, a stronger innate sense of structure, or a bigger talent for summoning up a community wherever they go than do the artists who stop making art. But every enduring artist has to struggle mightily with something—family opposition, lack of time, or fear of rejection, as examples—that makes it hard to keep on going. Every working artist has independently evolved methods to get past these personal obstacles, but sometimes these methods fail, and work stops. Sometimes too the artist loses sight of what he or she is trying to do; the focus blurs. That artist loses heart, and work stops. Even lifelong artists can get temporarily lost. But even if you have temporarily lost your focus, you can make room for making art again.

For many artists, the energy required to face and overcome these obstacles can become too great. The scale's balance shifts, and real life takes over. But real life doesn't automatically have to exclude art,

although that is the unspoken assumption. To the contrary. What artist looks back on his or her early education and still sees art as a filler, a frill, an elective? For me, chemistry was a frill. Art was, is, the necessity.

And it's harder for today's students. One of my sons *finally* got a chance to take a "fine arts" elective in public school—and he was assigned to a cooking class! The only time he was able to draw was in study hall. He was sternly rebuked for drawing, too, although his eyes did light up when the teacher threatened to call his mother.

"I basically feel that to live a real life, you cannot exclude the arts," says an artist interviewed for this book. The arts belong in every life, and for the visual artist the process of making art is an integral part of real life. The process gives something to that person nothing else can give. Therefore, when the experience of making art is lost, nothing can replace it. That's why it's so important for each artist to discover the art that he or she feels is worth making, to fight to hold on to that art, and to fight to regain the art if it has been lost.

It will always be a difficult thing to do. Some of the most insidious challenges to artists are societal, and these can be hard to identify while they're occurring. In the thirties, forties, and into the fifties artists grew up with many romantic notions about art and the lives artists were supposed to live. A potential obstacle that has developed fairly recently, on the other hand, is the equation of art with more traditional careers; the same standards of success are applied to each, with obvious disastrous results.

Of course artists can do a lot to help themselves. They can take their work seriously, and they certainly needn't consign themselves and their work to romantic obscurity. Still, it is unrealistic to expect a life in art to be similar to a life in banking. Unrealistic expectations lead to a situation that provides too ready an excuse for artists to stop working.

Each artist needs to clarify for himself or herself what constitutes achievement or success in art. What is a worthy, realistic goal for you?

My own goal is to keep on making art my whole life long. I want to make art regardless of conventional ideas of failure or success—I want to make art in *spite* of failure or success, in fact—I simply want to stay on my path.

When I explain this to others, they often act as though it is a very humble goal, but it isn't humble at all. True achievement is possible only with work; continuing to make art is no guarantee that you'll achieve what you want to with your art, but you can't achieve anything unless you continue to make the art. (To put it another way, you aren't likely to win the lottery, but you definitely won't win if you don't buy a ticket.)

One common contemporary idea about art is that artists do nothing but make art, that artists ruthlessly excise all extraneous elements from their lives. That's rarely the case. The artists I know have families, lovers, responsibilities, "money jobs."

It's an interesting thing, by the way, but when an artist asks another artist how his or her work is going, the answer is invariably about art. A retired teacher puts it this way: "I've always been employed, but I've also always worked." The art is the work, even though there is probably at least one money job in the artist's life.

Artists cope with bills, heartache, and illness just like everyone else, but they have made the process of making art a normal part of their everyday lives. Eight hours a day, two hours a day, an hour four times a week, or weekends and holidays: Enduring artists work when they can. Each has independently defined what it is to be an artist. None lets external definitions set the limits. Even though you will never hear of most of these artists, they are the people who have won.

An artist can renounce his or her art, art can disappear in the cumulative minutiae of daily life, or art can seep away in the studio even as you work. The realization that your connection to your most authentic art has been lost while you've been working at it can be the most devastating feeling of all. But there are ways to keep your art or to make room for it again, if it's been lost.

Remembering why you became an artist in the first place, how you first found your art, and what it is about your art that matters will enable you to see that finding your art again and again is the worthiest challenge you face.

# Making Room in Your World for Art

## Dealing with External Pressures

> **"The third part of the Prologue teaches us the great usefulness, joy, and delight which spring from painting."**
>
> **—Albrecht Dürer**

"STUDENTS HAVE ASKED me, 'How do you get to be an artist?' and the only answer I have to that is that it has to be so important that you can't live without doing it," says one artist. Another artist views this idea as "the romantic notion of the hard, gem-like flame artists are supposed to burn with."

This notion, unspoken much of the time, has resonance for many of us; it is something that we grow up with, and it exerts a subtle pressure. Some qualify it: "I'm not saying that it is 100 percent true, but I really believe in my heart that the best art is probably from people who feel that way." Others reject it, if reluctantly: "It was what I was raised on, but I don't think it holds water, really. If you're a homeless person and you're living in shelters, you've got other priorities."

Most artists, however, find themselves living lives that lie between those of the driven artists who put art before everything and the homeless artists who barely survive from one day to the next. These in-between artists have absorbed the same art legends as the rest of society. They may logically think, "I am not making art now, and I am still alive. I can live without making art. Therefore, I'm not really an artist; my art isn't important enough to me."

I feel that any art is worth making. That is, the act of creating the art is so positive to the creator—physically, emotionally, and spiritually—that the process is inherently worthwhile, regardless of the art that is made.

Of course artists are concerned with how their art looks and often with how it is received. Increased access to artworks of quality indirectly creates another pressure for the artist: How can he or she live up to the great works of the past? I can imagine how a rich child, growing up surrounded by art treasures, might feel creative energy

drain away. The masterworks might squelch rather than inspire that person. He or she might become a collector, a connoisseur, but an artist? It would take tremendous will. Imagine the amused shrugs, the raised eyebrows that would greet this young artist's "first five thousand mistakes," to paraphrase the Zen saying.

Today, ordinary people have greater firsthand exposure to extraordinary art than at any other time in history. We see so much art that is good that we lose sight of the struggle each of those artists went through to make the art. We don't see much of the failed work.

We revere dead artists and surround them with myth. We rush to museums, we order tickets to special traveling shows months in advance. We buy magazines and books about art and watch special television programs about artists. Our standards are high; we are used to seeing the best and can't help but compare our own work to it. We hear the cutting remark "Do you really think the world needs more bad paintings?" (or drawings, or sculpture) and it echoes in our burning ears.

My answer to that question is "Yes, I do think the world needs more bad art." That's how the world gets good art—not automatically, and not from every artist. But that's how the best art eventually happens. It doesn't drop from the sky.

And even if an artist were to know that his or her art would never be considered first-rate, I would still encourage that artist to persevere. Too many one-time artists say, almost proudly, "I looked around and realized I could never be really good, so I quit." It's easier to quit, but that doesn't make it the right thing for you to do.

Of course we, in our vanity and self-love, would rather see ourselves as first-rate artists, but I feel that it's an error to make important decisions about our lives based on such qualitative intangibles. For one thing, the way artists and their art are ranked and valued has a way of shifting as time passes. Often, even the most highly respected experts don't have much perspective on the art of their time; the "serious" art of just about any period is rarely the art that speaks to people a hundred years later.

And you might be wrong about your abilities. Many artists are filled with self-doubt and go through extended periods when they feel their work is of little worth.

Finally, even if you knew for a fact that being considered a "minor

artist" was the most to which you could aspire, making art would still be a worthy endeavor. "Minor" art is the art that is often most evocative of its time, most interesting to look at. But more important than that, someone made it. Be one of the creators; make the art.

Perhaps saying that art "has to be so important that you can't live without doing it" is putting it wrong. It might be more accurate to say, "Art is so important that artists can't feel fully alive without making it." It is therefore vital—necessary to life, a full life—that you, as an artist, make room in your world for art.

Apart from the vague burden of popular notions about artists and the pressure exerted by our ready contemporary access to only the best of history's art, today's artists face other common external pressures. They do so with varying degrees of grace, wiliness, and ingenuity. These pressures can sneak up on us.

For instance, even those closest to you can make it difficult to find or keep your art, and that's true even if the people around you think of themselves as art lovers. This awareness may come as a surprise, and such a discouraging experience can certainly create pressure.

But don't waste time or energy resenting these people. It's natural for them to fail to recognize the artists in their lives. They think of artists as "other people"; such an attitude is not a personal judgment on you or your abilities. Step around them and keep working.

It would really be the exceptional mother, child, friend, or coworker, after all, who could recognize the true self you reveal through your art. And are you able to see these people as clearly as they might wish? They have inner lives, too.

Don't take a negative attitude personally. You can, however, acknowledge to yourself that you will have to find your art community elsewhere.

There are different kinds of subterfuge that you may encounter from the people around you. It's up to you to recognize that subterfuge when it happens, and keep working anyway. Taking a look at some hypothetical situations provides examples of three levels of possible interference.

You might encounter outright hostility: "Why are you wasting your time on that junk?" "How much did all this stuff cost us, anyway?" or the famous "You call that art?" Your interest in art makes this person angry.

Perhaps you become aware of a more passive pressure: "You weren't going to work on your art today, were you?" "Wouldn't it be great if we got all that stuff cleared out of the spare room?" or "Why can't you go away with us over the weekend?" Realize that it is not in this person's best immediate interest for you to make art. It's that simple; his or her life would be a little easier, run a little smoother, if you were to give it up.

Maybe the interference you encounter comes more from ignorance, though: "Oh, you work on art every day? I thought you had to be in the mood!" "Since you only have a part-time job, I know you can help us out" or "Can't you do this for me now and work on your art later?"

I think the best approach to hostility is to say, "This is the way it is. Take it or leave it." If the hostile person is peripheral to your life, it may be necessary to turn away from him or her—to turn toward your art. If a person is actively campaigning against the best you see in yourself, perhaps some pruning is in order. How much could that person really care about you, after all? Such drastic reactions are seldom called for, though.

As for the ignorant or the passive complainers, you can, without trying to win them over, either educate them or, more likely, gradually accustom them to your priorities. If you don't answer your phone when you're working in the mornings, for instance, people will eventually stop calling then.

## *Your Childhood Family*

Your parents look at you and sometimes still see a colicky baby or a rebellious teen. Your sister sees the fiend who read her diary. Your cousin sees the kid who always got carsick on outings. It's no wonder that an artist's childhood family has a hard time seeing their grown relative as an artist! Even the storybook parents who were able to enroll their children in every available art class are usually a little taken aback when one of those children becomes an artist. "But, but—we just wanted you to express yourself, to appreciate art. Aren't you going a little overboard on this whole thing?" The number of privileged young people who encounter these family pressures is surprising.

But there is enough external pressure to go around, when it

comes to childhood families. Sometimes that pressure can even end up helping the art. One artist says, "Somebody who has grown up in a very normal household and had a happy, idyllic childhood might not have experienced the same things I did and probably doesn't see the world the way I do." She goes on: "I tend to think that some measure of tension and adversity probably can push you into compensating some way and can really enhance your artistic life."

Not that artists need to have a background of acute suffering to make art. I think that being able to feel empathy matters much more than having experienced misery, and the two don't necessarily go hand in hand. But one of the most interesting things I found in talking with other artists is that a privileged or middle-class background can sometimes be harder for an artist to overcome, at least emotionally, than a financially disadvantaged one. For instance, one artist who describes his upbringing as "middle class" says, "I did eventually go to art school, but against parental wishes, so Industrial Design seemed a good compromise. But an animator from Walt Disney Studios quit and opened an art store across the street from school. He spotted me as a weak-willed young man who was hopelessly on the wrong path and decided to subvert me."

Another artist, growing up far poorer, says that he never once felt undermined by his family. He explains, "You have to understand that I grew up with a total art void. No art at all. My family didn't know what art is. I went to art school because my GI Bill was running out and I wanted to use it. That was really the motivation of why I went at that particular time." He goes on: "I never needed family support for my art. I never even thought about it. Oh, they support me 100 percent, but they don't understand me." He laughs and adds that his sister still says, speaking about his art, "I never knew this about you! I don't know where it came from."

LaMonte Westmoreland tells a remarkable story of his art beginnings—and of family unity and support. He says, "When I was growing up in Wisconsin, I had no idea what I wanted to do. As a matter of fact, college was not something black people did. There weren't any role models for me to look at and say, 'Wow, they went to college.' Everybody that got out of high school, if they finished high school, worked in the factory.

"But my oldest brother was a fabulous artist, and he received a

scholarship to the Minnesota Art Institute. This was a great thing, and you *know* I was bragging all over the place: 'My brother's going to college. He's going to college!' I used to stay up late at night after he came home from work—about eleven or twelve o'clock. He would go into the kitchen, lay his stuff out, and I would sit in the living room in the dark and watch him draw. He didn't want anyone disturbing him, but he would always show me the work. I don't think he ever showed anyone else. It was just super—we had a good relationship.

"And then my brother fell in love and got married and didn't go to college. This all happened during the summer, and it was kind of devastating to me. So I just said, 'If he's not going to do it, I have to do it.' " When LaMonte and a cousin announced they were going to go to art school in California, he says, "I had support, because nobody from the black community even talked about going to school. But we did it."

Sometimes, families provide support or inspiration in indirect, unintentional ways. For instance, a child might think, while growing up, "My father is a doctor. He makes a lot of money, and I like that part. But he hardly ever gets to enjoy it. He doesn't even seem to like being a doctor any more. Who wants to live like that? I don't." Or a child might say to himself or herself, "My mother is a Sunday-painter kind of artist and she's good, but she's miserable. Why didn't she ever take her art more seriously? I don't want to make that same mistake."

Artists tell stories of their families indirectly influencing them in positive ways too, of course. Virginia Cartwright, an inspired teacher as well as artist, recalls the time in her life when, eager to start teaching at last, she was unable to get a job. She says, "Every place I went, nothing available. Then I thought about my dad: He had a degree in physics, and during the war there were no jobs at all, but he had a family and some little kids to support. So he went to a local gas station and asked if he could pump gas. They said, 'No, we have one guy. We can't afford another one.' So he said, 'I'll tell you what—I'll work free for three weeks, and then if you decide you can do without me, that's OK.'

"So I thought, 'You want to teach; get together a workshop.' I had never given a workshop before. 'Get together a slide show and a little demo, and give it free to places.' So that's what I did, and every place I gave it, they ended up offering me a job."

*Laocoön Group with Cream of Wheat,* **LaMonte Westmoreland,** collage and body print, 37 ¹/₂″ × 27 ³/₄″. Photo by LaMonte Westmoreland.

Probably all members of our childhood families have lessons to teach, whether positive or negative, that can help us as artists. The challenge is to absorb those lessons, accept those indirect gifts, without wanting more. And empathize with your family. One artist says, "I think they worry, and the older I get, the more I understand why they do."

Some artists, whatever their backgrounds, carry a "Look what I can do!" attitude with them into adulthood. They still want their childhood family's attention. The trouble with this attitude is that our families are seldom impressed by the right things, so we may try to impress them with the wrong things, thus compromising our own hard-won perspective. Families tend to focus on past or future accomplishments—publicity, shows, awards—rather than present work. And they probably judge accomplishments by a different standard than the one you use: You may sell a painting for $800, but a lawyer can make that much in a single morning, your mother might point out. You may have a one-person show in a college gallery, but didn't it cost you more to frame and ship the work than you made in sales, your brother asks? Your family might wonder how you can call that show a success.

No matter who you are, there will be relatively few tangible triumphs in a life spent making art: For you, the artist, satisfaction has to come instead from your feelings about your art and the creative process. If you allow yourself to be dragged into the trap of trying to impress your childhood family, using their standards of success, you will inevitably end up feeling as if you have failed.

It is unrealistic and unfair to expect people unfamiliar with the creative process to respond to your art the way you wish they would. The fact that these people are related to you simply makes you feel disappointment at their lack of understanding more keenly. You're probably expecting too much from them. If you're an artist who searches in vain for the "right" kind of admiration from your childhood family, concentrate on the gifts they have to offer rather than on the ways those people disappoint you. Stop trying to get something from them they cannot possibly give, and turn elsewhere for the affirmation you need.

And you can always take secret comfort in the awareness that even the most infuriating family response to your art becomes insignificant as time passes. After all, when you think about art and artists,

do you think about their families too? Apart from Theo van Gogh—that saint!—or Whistler's mother—that profile!—what artist's family member can you even remember?

## *Your Adult Family*

If you have a committed relationship, marry, or have children, you have an additional family—your adult family—and there are then different, more immediate external pressures to face and overcome. Some of these pressures are practical ones: Where will you live? "New York was obviously Mecca," remembers Doug McClellan, "but we came west temporarily and stayed—fifty years now." Your money job, your partner's job, school districts; more and more nonart issues must be weighed in every decision as your domestic life becomes increasingly complicated.

If you and your partner both are artists, who gets to make the art when pressures multiply? One artist says that his artist wife "was not making art while I was, because she was raising the children." When asked about the pull between a family's needs and an artist's needs, a lifelong artist acknowledges, "There was always that tension, yeah."

You can't always tell in advance the ways having children will affect your art, either. Claire Henze says, "I have the responsibility that I have to take care of my kids, so I'm not going to go out shooting in downtown L.A. at 4 A.M." Risks you were willing to take when living alone can suddenly seem too great.

But interestingly, we tend to anticipate only the negative impact children will have upon our art. Children can have a positive influence, too. In a broad sense, having children causes you to change your perspective on the world: You love your children, and the world seems more precious when you're in love. In addition, young children force you to slow down and look at your surroundings. They make you feel more vulnerable, more helpless. You can become more human, and that makes you a better artist.

In a practical sense, your children's demands provide a structure that may be helpful to your work, even if you feel that you're up against that structure rather than supported by it. Children can provide a sort of emotional centrifugal force: Barring complete catastrophe, you can't ever fall completely apart. Someone has to

make the oatmeal every morning. Children's demands don't quit, no matter what is happening in the rest of your life.

In the long run, to look at it myopically, if optimistically, that domestic drudgery can be translated into studio routine. The discipline required for each is similar.

Everything costs something; even choices have a price. When you choose art, you are asking your partner, your children, to pay part of that price, and you may feel reluctant to do that. But if the alternative is living a life in which you can't feel you are fully yourself, fully alive, what does a little reluctance matter? Focus instead on what you're *giving* your family through your life as an artist: "I was able to enrich their lives with art," says one artist with confidence. Many artists with grown children tell me of their children's high regard for the arts, regardless of the careers those children have chosen. Young children may complain about your wandering attention, about your reluctance to leave the studio, even about tight finances, lack of space, or the way you're dressed when you pick them up at school. When they grow up, however, they usually see past those things and recognize the value of what you have done, for yourself and for them.

As with your childhood family, don't expect more from your adult family than they are able to give. Your adult family might not be part of your eventual art community, either. But, since they have only known you as an artist, that family is much more apt to see you the way you see yourself than is your childhood family. Your values are communicated to your adult family every day through your actions. If your family is able to support you, fine. If, through the hostility, passive pressure, or ignorance discussed earlier in this chapter you feel that your adult family is working against you, you must either change their attitudes or change the way you react to those attitudes. Again, your actions—in going to the studio and working—are what count; those actions speak louder to the most obstructive adult family member than any number of words.

## Friends

It is through our friends that we, as artists, are most likely to discover the community we need. We choose our friends. As adults, we have some old friends from childhood or school, and we

continue to make new friends, perhaps more slowly, as time passes. But every friend wants the best for us and shares something with us, whether it is memories, the same work place or outside interest, or a similar way of looking at things.

Art is not necessarily that shared interest; obviously, not all of your friends will be artists. Harrison Storms describes friendship with his fellow teachers: "Most of the people I know are not artists, but they're supportive in the sense that they wish me well." This mild assessment probably describes the ideal friendship not based on art: It's a relationship of mutual support.

Art friends are important to every artist, and such friends support one another as a matter of course. The only time that I have felt that minimum of support lacking between artists has been when one or both of the artists is very young. Then, the competitive stance can take over. I'm sometimes reminded of nature programs in which animals bristle and posture, with genetic survival as the ultimate goal. This attitude is something to outgrow. Artists want to survive too, of course, and an aura of confidence and invulnerability can help, at least in dealing with the satellite worlds of art. But it's too bad when potential artist friends turn these brittle sides to one another. It increases each artist's feeling of isolation and deprives him or her of a possible means of emotional support. And it's so unnecessary.

An artist I spoke with only a few months ago recalled a distant, fervent if cliché-ridden party conversation we'd had. Apparently I'd maintained that we should feel happy when another artist gets "a piece of the pie," as there is enough pie for everyone, and another's success probably makes the pie bigger, anyway. He had disagreed at the time, arguing that each artist has to fight for every piece of pie, because the amount of pie is limited. He remembered this confusing exchange far better than I, but as his point was that he had changed his mind and now felt I was right, I was happy to take credit.

Of course we both could be wrong, or perhaps only a little right, and I probably should also point out that neither of us has had tremendous pie experience. But my point is that the competitive atmosphere that surrounds everyone today can deprive artists of a valuable creative resource—other artists. And ask yourself, who benefits when artists accept as true the assertion that countless other artists are fighting for the same display space, for the same collec-

tors, for the same so-called "art dollar"? It's not the artists who benefit. There will always be people who like to remind artists that there are "plenty more where you come from," and there will always be artists who believe it. I'm not one of them.

Most enduring artists have made it past the posturing. They are people who have learned to reveal their doubts and vulnerability to selected artist friends. They try to help other artists, and they are able to take an almost personal pleasure in the success of others. Sheba Sharrow points out a practical reason for searching out artist friends: "I have a lot of friends who are not artists, and I suppose we have other issues in common. However, I can say that I long for artist friends, because I know that we are dealing with the same problems and we're having the same struggles. It's very comforting to be able to compare notes with somebody else, and to talk about art, and to express your opinions about this painter or that painter. The other person knows what you're talking about." Many artists share her yearning and actively search for ways to satisfy it.

Some artists anticipate this need early: "I had a good instinct leaving school that I would want to be around friends who were also artists. I'm really glad I followed that instinct, because that sense of support and shared instincts and mutual kicks in the butt to keep on going has been really important."

Sometimes a friend plays a pivotal role in an artist's creative life. Jerry Barrish describes the confidence a friend gave him at a crucial time: "I made sculpture for a year, accumulated a body of work, and showed it to a friend of mine—Stuart Harwood. He's a sculptor. He said, 'This stuff is great!' "

Some artists stress the professional importance of an art community: "Get out there and network. It's clear to me that that's how a lot of the success happens," says one. LaMonte Westmoreland describes a year that was especially valuable to him: "One of the good things that the African American artists did—we would meet up at David Hammons's studio on Thursday nights, and we would be up there almost all night long, critiquing each other's work and talking about social problems. About how to get younger African American artists in school to take their work seriously. Just a whole gang of people, and it was really great."

Artists don't always talk about art with each other, of course. In fact, they often don't talk about it at all. I used to joke that what

artists really like to talk about is food and sex! But even those conversations are probably beneficial to the art, in some way.

One of the best descriptions of the most valuable kind of mutual friendship between artists comes from Jerry Barrish, who says, "I have a lot of acquaintances, artists whose work is totally different from mine. We don't really talk about each other's art. There's no jealousy or anything—I mean, I don't feel it. *We like each other for what we're trying to do.*" To admire and understand someone's creative goals—what better way could there be to demonstrate friendship? And as the recipient of such goodwill, you're more likely to value that admiration, that understanding, because it has come from a fellow artist.

There are ways to find the friends that will enlarge your art community. Some artists continue to take classes for the access they provide to specialized photography, printmaking, or ceramics equipment. These classes also provide an external structure that can stimulate independent work. But best of all, for some, these classes provide the opportunity to be around other artists.

Art colonies exist to give artists a place to do concentrated, uninterrupted work. But if you're lucky enough to be invited to a colony, you are likely to make new art friends, too.

If you meet other artists while traveling and you make some sort of aesthetic or emotional connection, don't lose that person. I correspond with some people I've met while at art colonies, for instance—writers, composers, and visual artists—and I count them as part of my art community. Although our activities are varied, our priorities are similar. A letter from one of these friends is a comfort, a reminder that I'm not alone, even when I shut the studio door.

There are other potential art friends in every artist's life, although the artist might not always recognize them as such. I almost always feel some kinship with an artist, for instance, when I read his or her biography or autobiography. Such books also present a realistic picture of the rejection and disappointments even the most "successful" artist experiences. The artists you read about can be friends, in a way.

And then there are mentors. Mentors don't always know they are being mentors; you might not even realize that someone has served this role for you until some time has passed, then you look back and realize all the different things this person taught you.

People you have never met can also fill this role for you. Choose whomever you wish! Many of the artists included in this book have mentors, role models, or heroes they've never met.

However you manage it, and however solitary you are by nature, work to develop and slowly enlarge your circle of art friends. This will help you overcome the pressure of isolation. You have a better chance of staying an artist if there are people in your life who understand the way you feel about your art and love the things you love. These are the people who like you for what you're trying to do.

## *Job*

Artists often choose money jobs that give them the greatest access to studio time. They try to find jobs that don't use up more than their fair share of energy. And if they're smart, artists take the time to recognize and appreciate the things those necessary jobs give them rather than to resent what they don't.

There are differing opinions on the subject of how separate art should be kept from the money jobs. One artist laughingly calls this "the pumping gas question," in reference to the old coffee house argument, "Wouldn't it be better to pump gas than to compromise your art?"

Some artists believe firmly in keeping art far removed from their money jobs. Stephanie Rowden says, "I've done a lot of things—waitressing, house cleaning, temp work." Speaking of her office job, she says, "It is fairly regular. I like that about my job. I would like that always to be the case with how I make money, to have it be very steady. That took me a while to figure out." She comments that if she had to spend a lot of energy "hustling jobs," she wouldn't have the energy left to hustle her art.

Jerry Barrish agrees. Speaking of the business he has developed, he says, "This was all preconceived. This was always my goal, to have my job be independent from my art."

The two most readily apparent results of this decision are financial and aesthetic: The artist's ability to cover living expenses is not dependent on how well his or her art is being received, and that artist feels less subsequent pressure to tailor his or her art to external demands. Another result of keeping the art and money job separate, though, is a split in the artist's world. That artist ends up with

completely different circles of acquaintance, each one seeing that person differently. This is invigorating for some, but others might perceive it as a negative, a drain.

Teaching art is a solution for many artists. It gives them time to work on art—school holidays and the summer, at least, and studio time during the week, if the artist teaches at college level—and art teachers can usually retain their artistic identities. There are other positives to teaching, too. "I get to try out new ideas on how to think about art, and the students challenge me," says one artist. Another artist comments, "It's strange, but just being around that energy all day, it kind of works into my system." Yet others feel that teaching knocks them out.

Sheba Sharrow recalls her early teaching years: "When I started out in 1968, it was with a great sense of mission. I was going to go in and bring the gospel to all these heathens. And then ironically I found myself teaching in a geographical area that considered art the devil's handmaiden. I mean that, absolutely. It affected me negatively in that it caused a lot of stress and tension, and I had to work against all that. But the students were very enthusiastic and responsive, and that was the positive thing about teaching."

Another thing that teaching gives artists is an opportunity to be around other people. Every artist I talked with mentioned the need to be around others. I am probably the most reclusive artist in this book, and *I* need to be around people. Artists who don't teach or work with others find other ways to be with people. Many go out for coffee or a meal, even a solitary meal, both to break the spell of the studio and for human contact. Some artists establish a daily routine that ensures contact, however impersonal, with others. A trip to the library, the gym, or the store might suffice.

And something I've experienced in common with other artists points out an additional hidden benefit to teaching art: You are forced to clarify your aesthetic opinions, however slowly, and this often can bring your own art into clearer focus. So teaching can end up helping your art.

There are negative aspects to teaching, of course. Education isn't valued very highly by much of society, and art is valued even less. The teacher has to make his or her peace with those facts—and that salary.

Art programs are among the first to be cut when times are hard,

so art teachers have even less job security than do other teachers. And it's so hard to get a full-time college level teaching position now, that many artists are caught in a part-time teaching trap, waiting for a full-time position to open. These artists often end up bearing a greater than full-time load, teaching at several schools with no benefits or job security. One such "part-time" teacher in his mid-forties, speaking of health insurance, says, "I bought it about three years ago, so I have to do everything I can do to keep it." He was teaching at three schools when he bought his own policy, and he says that after his rent, it's his primary expense.

There are artists who make a living solely from their art, and some of them do very well, but there's always a lot of extraneous work involved, and there's more work as the artist becomes more re-nowned. Some artists are able to hire assistants to do specific tasks under their direction, but these tasks—documenting work, selling work, writing letters, applying for commissions or grants—still take up much of the artist's own time. One such artist is known for rising at 3 A.M. and working on his art until about 9 A.M. The entire rest of his day is spent with assistants, conducting studio business!

## *Career*

A job is important, but the word "career" has a different sound to it. "Career" usually connotes a high degree of training, a lifelong commitment, and a certain standing in society. The word thus refers to the way the person with the career sees his or her work, but it also has come to be tied to rank, to class.

Consider the simple question, "Is art a career?" The artist is part of contemporary life and sometimes seeks to establish where he or she fits in. How much more gratifying to be ranked with doctors or lawyers than with the rest of the mob! And, as artists today are likely to have gone through both college and graduate school, they feel entitled to give their work the "career" label. They take their work seriously and want others to as well.

This question is another one on which artists hold differing opinions, however. I think that it is an important question, because each artist's reaction to it will help him or her recognize additional pressure he or she is likely to be feeling. There is no right answer to the question, but an artist will benefit from formulating an answer

that feels right. The writer Richard Ford says, "I don't think writers have careers—my work doesn't exist separately from my life."[2] One artist concurs: "When I think of a career, I think of a job."

Some artists have mixed feelings about this assessment. Says one, "In my own case, I never thought of it as a career. Well, that's probably dishonest. In the fifties, I was getting into shows and all that stuff."

If art is a career, it is not like other careers, and I think it is important for artists to recognize this. I believe that expecting art to have the potential to be a career like any other presents such an elusive goal that it invites unnecessary external pressure into your life. This expectation makes it far less likely that you will ever be able to feel that you have succeeded, and it is apt to shorten your creative life.

How is art different from more traditional careers? For one thing, the word "career" usually implies that a living is made, and not many artists have ever been able to make a consistent living directly from their art. Maybe this will change some day, but I don't think it's likely to.

Furthermore, a definition of the word "career" usually contains reference to speed, or at least steady progress. In a traditional career, a person can expect a logical sequence of rewards for steady work. But while the artist might know that his or her work in the studio is progressing steadily, that progress is often unmatched by outside recognition. Sometimes the recognition won't come until many years after the studio achievement. Try taking that to the bank!

And unlike most career-oriented people, artists find their work shifting in and out of favor for reasons that have nothing to do with the quality of the work. This is apparent when you read almost any artist's biography or autobiography.

When a person running a restaurant experiences external success, that success often can be built upon to create more success. Artists, however, are more likely to have to keep starting over. Even at the conclusion of a sold out one-person show, no one will come up to the artist and say, "Have you ever considered franchising?" Instead, the attitude is, "Great, but what are you going to do next?" That will never change, either.

But dismissing society's need to establish pecking order through labels, we artists are still left with a desire to tell the truth about the

importance of the work we do. That leaves us with the "career" label. No, an artist's work doesn't exist separately from his or her life, and no, making art is not like any other job, but artists can certainly benefit when they take their work seriously and demand that others do the same. So although art is not a career in the traditional sense of the word, artists should treat it as though it were.

## The Price

Do lifelong artists pay a price for having chosen to make art? Of course. As I stated before, everyone pays the price for his or her choices. The cliché of the "suffering artist" gives young artists a glimmer of what may await them, perhaps even of what is expected of them. This sneak preview creates anticipatory pressure for the artist. One artist who resisted this pressure recalls being negatively influenced by a popular book about van Gogh: "I read *Lust for Life,* and I knew I wasn't willing to make *that* kind of commitment!"

Self-mutilation aside, what tangible price does the artist pay for a life in art? "One of the biggest things is the idea of owning a lot of stuff, lowering my standard of living a lot," one artist says. He adds, "You've got to be careful that you don't see yourself as a victim."

Another artist, though better off financially, says, "I probably could have made a great deal of money if that's all I wanted to do, but I didn't, because I needed the time to do other things. It cost me a lot of money to pay people to work so I could have the time for art."

Price doesn't simply mean money, of course. One artist says, "I'm sure it's affected how many children I've decided to have. The times in your life where you put in all this energy and time, and it's just not panning out financially or emotionally—in those times, I get really angry. I think that's the one sad thing."

Another artist describes his early efforts to afford both a studio and the time to work in it: "I would find people; I'd do something for them, and they'd let me live in a room. It ruins your social life, and you're thought of as a freeloader a lot by friends."

Some artists pay a physical price for making art. For one thing, many artists have no health insurance, so any medical treatment they receive is apt to be emergency treatment. An artist friend of mine,

dying far too young, spent many of his final hours in a state of anxiety, fearful that the hospital would make him leave because he didn't have insurance.

Artists point out specific physical problems caused by their art: "My back. And maybe I'm looking for materials in toxic waste dumps for all I know. Where I pick this stuff up, who knows what I'm exposed to? And I have to wash and clean it." He goes on: "I have friends who have really paid the price. People who work in stone have marble dust in their lungs." Other artists mentioned respiratory problems, or lead poisoning, or violent headaches, all caused by the materials they have used.

The intangible price artists pay for their art is harder to measure, but it exists. Artists have to create many things for themselves, such as the structure and community that others take for granted. This creates emotional pressure. So does "rejection or lack of recognition," says an artist who adds, "I think the biggest price you pay is to keep going when things are not going well for you. It's really easy to quit, and there has to be something that allows you to keep going." But the process can take something out of you.

You might feel the pressure of geographical isolation, whether you live in the country or the suburbs, if there are no good museums, galleries, or art supply stores nearby. Books, magazines, and art supply catalogs can help overcome this kind of isolation, as can art friends. Traveling can help too, and, if all else fails, so can moving.

You might feel emotional isolation if there is no one around with similar priorities. You can feel spiritually isolated if nobody you know cares about the things you value most. Recognize the isolation you feel and try to compensate for the pressure it creates.

And then there is the pressure that results from going against society's general view of what constitutes a productive life. One artist says, "The consequences of doing something like this socially is a price; I mean, you've got to pay the price. You've got to feel it's worth it."

Artists are part of the world, yet they have to stand apart from the world in a way. Recalling his youth, the writer V.S. Pritchett says, "I saw very little of England for seven years . . . I became a foreigner. For myself that is what a writer is—a man living on the other side of a frontier."[3] I think that's the artist's natural stance, but it's hard at

*The Travelling Crystal Ball Room,* **Stephanie Rowden,** mixed media, audio installation, 12′ × 12′ × 5′. Photo by Ruby Levesque.

times to reconcile yourself to the value of it. That outsider stance has its price. An artist describes one way it can feel: "You just become kind of like a voyeur, a voyeur of life."

I think this feeling of estrangement is sensed by others and is one of the sources of the generalized hostility society feels toward its artists. This hostility can, in turn, become another external pressure making it harder for the artist to make art.

What makes art all worth doing in spite of these assorted pressures? Each artist has to answer that question for himself or herself. Think about it: Perhaps you feel you can't be fully alive without making art; perhaps art provides you access to worlds you never knew existed when you were growing up. It could be that you feel truly "at home" only within the art community or in your studio. You might even feel that you never really had any other choice.

An awareness of what makes art worthwhile can give you the determination to deal with and overcome the pressures you face, and that awareness can give you the strength to make room in your world for art.

# Some Creative Requirements

## Time, Space, Money

> **"A rain-tight roof, frugal living, a box of colors, and God's sunlight through clear windows keep the soul attuned and the body vigorous for one's daily work."**
> **—Albert Pinkham Ryder**

THE DEMANDS OF a busy life make it challenging to be an artist. But I'll tell you a secret: I've talked with artists whose lives are settled. Their children are grown, *they* have enough money, they even have a studio, and they have trouble closing the studio door and getting to work. The truth is, even though artists feel an urge to create, they often pull away from the act of creation.

This can happen to anyone. One working artist says, "You know, I call somebody or do something else. And I've thought about why that is, because you'd think you wouldn't put off something that you're looking forward to doing." It's happened to me too; a bad day in the studio makes folding laundry appealing. It can seem like a mystery, but I think the feeling is often misinterpreted by the artist. "I'm lazy," "I'm just not dedicated enough," or "I guess I don't really have enough to say," he or she might worry. But there are two other ways to look at this contradictory impulse.

First, consider it as a natural struggle between opposing forces, creation and inertia. The struggle will always exist. Unfortunately, you're the equivalent of the wishbone in this struggle, which is the reason you feel so uncomfortable!

The second way to look at this contradiction is less cosmic, more practical: It's almost always easier not to do something than it is to do the thing, and people usually do what's easy. For an artist, though, some degree of misery ensues, because the creative urge is such a strong one.

All artists need time, space, and money to make art. Some artists are able to set their artistic priorities and stick with them, but why do so many artists tend to put these creative requirements last in their

lives? The single-parent artist who says "we're so much in the habit of putting ourselves last" is aware of this.

Sometimes an artist makes the decision to give his or her creative requirements top priority, and that artist is willing to pay the price. A painter notes that he has given up many things in his life "not only to afford the studio, but to afford time."

If you can fight inertia and provide yourself with a mental structure for your creativity, then the physical structure won't seem so hard. The mental structure is built around the central question "Why am I an artist?" and is central to your life. The physical structure of how you make the art can seem more important, more overwhelming, though, because those practical creative requirements, time, space, and money are the ones you deal with every day.

## Time

Still, finding time for art preoccupies most artists. For years, I have regularly gone through a process I think of as "carving out hours" in planning weekly studio time, and that doesn't sound like a very gentle process, does it?

Like everyone trying to do more than one job, artists lead busy lives. One artist reflects, "You know, it wasn't just the teaching. It was always being chairman of the department. But I always worked. Sometimes it was fragmentary as hell, and sometimes it was unproductive, but I always worked."

Combining family, employment, and art is a real challenge. LaMonte Westmoreland, married and the father of two grown sons, recalls, "For a period there I was teaching full time at the high school, Monday and Wednesday nights at Pasadena City College, Tuesday and Thursday nights at Santa Monica City College, and I was running the school gallery, too. Friday, Saturday, and Sunday it was studio time."

He has evolved different studio schedules over the years, and his schedule is less strenuous now, thank goodness. But his wife says he always valued family life highly, as he still does. He himself says his wife always valued his art, then adds, "I always tried not to sacrifice too much of the family situation for the art. That's kind of a hard balance to do."

One artist confides that she sometimes feels much busier than other artists. She feels there are more details cluttering up her life. Then she says, "But everyone has interruptions in their lives. I mean, even those guys who are on the fast track. Everybody has somebody die, they get sick, whatever." Whatever.

Doug McClellan recalls, "When I first started teaching, I painted in the bedroom. I remember the baby looked up and saw this painting—a brooding silhouette of a self-portrait—and cried." He adds, "I had gotten this advice when I got my MFA: 'Go to the studio all the time, whether you feel like it or not.' My first year of teaching, I taught five classes, night class, and was chairman of the department."

He goes on to explain, "I had a commitment to a one-person show every other year in Los Angeles and was meeting that obligation. I did that for nine or ten years, so I did get some work done. I don't think I grew very damn much, not in my work. But I did it."

A painter remembers, "Everything, of course, was secondary to the other responsibilities I had. Somehow the painting came last, but it still always had to be there." Another artist recalls a similar situation: "I was always fighting for time. Nights, after we had our evenings together, like 9 P.M. or so, I'd go out there and work until 11 or 12. I didn't feel so bad about that."

Those artists' early years don't sound great, do they? But they're typical, I think, although these are the artists who continued to make art. But it's no wonder that many artists lose their art during this time. Unless you feel a strong compulsion to continue, and unless the circumstances of your life allow at least the glimmer of a chance for the art to happen, your creative life can evaporate.

What about the middle years? What are some of the structures artists have evolved so that they can continue to make their art? First, there's the dogged approach. In my own life, my basic studio schedule for ten years was built around caring for my two young sons and teaching part time. I was lucky in that my teaching schedule enabled me to have more studio hours. Of course, one of the main reasons I took that job was to make the studio hours possible. My system was to look at each semester's schedule with the goal of a specific number of studio hours per week in mind; my

average figure was an optimistic thirty-two hours a week, as I recall. Then I'd find the hours. I'd block them out on a calendar. It was tenuous at times, but it was a structure. I thought of this as the "slow but steady" approach, and it suited me.

Harrison Storms is a dogged worker, too. He says, "Unless I'm teaching, I work every day. I usually get to the studio by eight o'clock. Sometimes I go home for lunch, because I live close, but then I just work until four or five o'clock. These paintings are incredibly labor intensive." A sculptor describes his approach when he says, "You have two hours, so you work for two hours. I think that's an asset, really. You can't wait for inspiration."

And then there's the "forty-yard dash" approach. One artist tells me, "I have these binges of creativity that are sort of unpredictable. Maybe I'll work all day Sunday, and then I won't work at all during the week." She adds that when she has a deadline, "then I work like crazy. I work constantly. I'll work all night, if necessary." Some artists work best in bursts of energy, but productive artists tend to have consistent bursts, when looked at over a long period of time.

Another artist usually has one big sale a year, in addition to other exhibitions. She says, "I always wait until like three to four months before the sale, and then I just go. I seem to work best under pressure."

Most artists simply have to fit their studio work into available hours. "You need to stop and remember that you're really doing several full-time jobs, so I fit it in when I can. Usually the big blocks of time are on the weekend and summer."

A former teacher recalls that he used to work on his art "mostly in the summer, at home, and at the beach." He considered much of the summer artwork as essentially recreational, by the way, less significant than his year-round efforts. Now when he looks back he recognizes that his summer art is some of his most interesting work.

One artist tells me, "When I'm teaching full time and I have a couple of part-time jobs, I really don't have the energy all the time to get into the studio, so I almost work for vacation times—two weeks at Christmas, a week at Easter, summer." He adds, "But I always try to formulate ideas and get to the studio as much as possible the rest of the time during the year." He often spends time in his studio, even if he can't work, "just so I can get there in that physical space."

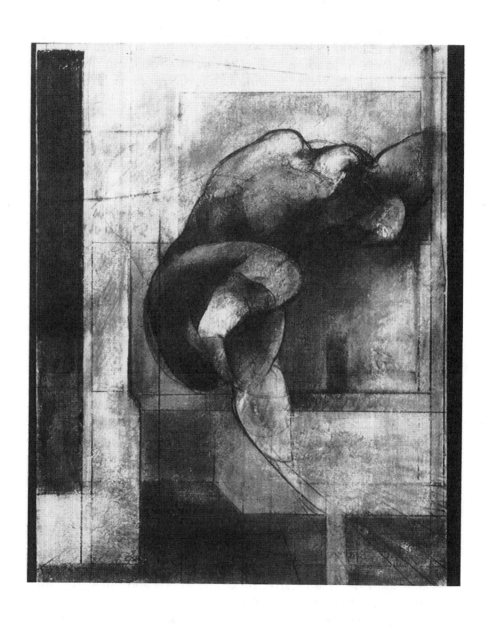

*Beyond the Wall #13,* **Harrison Storms,** acrylic on masonite, 64″ × 48″.
Photo by Harrison Storms.

If an artist has the choice, when is his or her ideal time of day to work in the studio? Many artists I asked mentioned morning, at least for their most demanding work. I'm this way, too; I can't remember the last time I started a drawing in the afternoon or evening, for instance.

Another artist agrees. "Morning. I can't work at night. It could be energy, it could be habit, it could be just that's the way it is. I don't know." A painter says that her ideal working day is "starting from midmorning to when the sun goes down. I like to work with the daylight."

Not everyone works well in the morning, of course. Jerry Barrish says, "I'm sort of a night-owl person. I socialize at night, I can't work at night. I usually work afternoons." He adds that he likes to walk on the beach about two times a week to find materials for his assemblage sculpture.

But Sheba Sharrow points out something important: "Time—in some instances, you simply have to make the time. You have to be motivated enough to say, 'What is the most important thing that I have to do right now?' And that's, I think, the biggest hurdle to cross. Once you do that, everything else becomes secondary. You can make the time."

Something that interests me is the amount of time—lots—that an artist spends thinking about art when he or she is away from the studio. Making art isn't like adjusting widgets, after all. A lot of thought, dreaming, and intuition are involved. Every artist brought this up, and each has his or her own way of getting the most from this time. "One of the best times for thinking about art is in bed, in the early morning, before I'm completely awake—before I open my eyes," says one. "Because you're sort of drifting. You seem to be floating, and I tend to make free associations a lot during that time."

Another artist talks about sleep: "I have a little bit of insomnia. I wake up in the middle of the night sometimes for two, three, four hours, and I use it as creative time. I lie in bed and think. It's just a matter of utilizing that time when I'm awake."

Several artists mentioned the time spent driving as prime thinking time. So watch out!

And then there are what I refer to as "studio chores," the happy puttering that can end up being productive time. Harrison Storms says, "Sometimes I'm just looking at the work. Every so often I'll

build stuff. I always like that, because it's so straightforward. You know what the answer is." That can be a relief from the uncertainties of making art.

How often are artists thinking about their art? "Theoretically, I could say I never stop," says one artist who could be speaking for many. "I spend twenty-four hours a day on my art, thinking about it." "All the time I'm not talking directly to someone else," says another. "It's always at different levels of consciousness." "Now I give more respect to the multiple parts of it all rather than just the product," says a third artist.

What are artists thinking about? One artist explains: "Sometimes it's a specific project, and I'll be trying to work it out in my head, or visualizing how it's going to look, or how I'm going to accomplish it technically." LaMonte Westmoreland says, "I think about a particular series that I want to get involved with, and generally what happens, you know, that spark takes over." "Sometimes it's just an ongoing observation, being really aware, and saying, 'Look at that negative shape,' " says Virginia Cartwright. "And then there's other times when it's real specific: 'How many pieces am I going to have in this show, and how shall I group them?' "

I find that I have to plan shows physically. I actually have to "pace off" a gallery and stare at the walls, envisioning my work there. My own thoughts about my art are more like pictures; they sometimes have to do with proportion, the relationship of the image to the paper. People who see my work are seldom aware of these relationships, by the way. I also think about past work. In fact, that's when I usually come closest to figuring out what I've been doing!

Did you know that even fractured studio time adds up when you're consistent? This was a revelation to me, and it took me many years of struggle to learn it. I only recently read an interview in the *Scripps College Bulletin* in which a woman in her late fifties said that she always knew she would paint for eight hours a day regardless of what else she needed to do, and that was what had happened. I always used to think that's the way it had to be. I'm glad things went so smoothly for this artist, but I don't know anyone else whose life has worked out that way. Most artists have learned the hard way that they simply have to piece it together and work on their art whenever they get the chance.

Still, the results can be remarkable. Says one artist, "People will

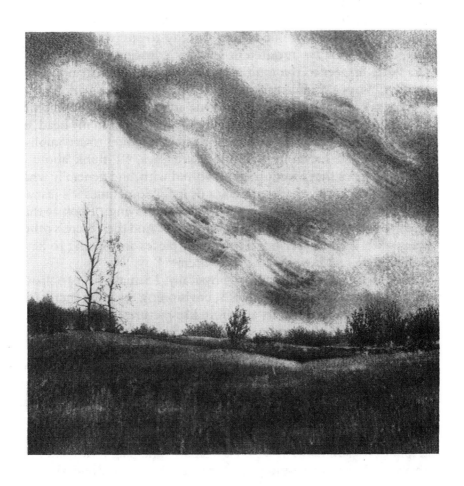

*Scofield Farm/Storm,* **Sally Warner,** charcoal on paper, 6" × 6". Photo
by Mel Schockner.

say, 'You've gone so far, you've done so much!' And I think, 'It's just a little here and a little there.' "

Sometimes this necessarily fragmented approach has hidden benefits. I often return to the studio and suddenly reevaluate what I was planning to do next on a piece. The break in time has given me a different perspective.

Virginia Cartwright recalls a similar experience. She remembers working on a clay piece, "and I found that things came up, and I had to keep it moist for day after day. I couldn't get back to it. And by the time I got back to it, something had happened in my life. I'd seen something that made the piece ready to be completed." She adds, "I find that's happening a lot, where it's OK to have it disrupted, because in that time you learn something important for the piece."

Some version of the "slow but steady," dogged approach is effective if you are attempting to rediscover your most authentic art. If you can only work on your art two hours each week, for instance, make sure to work that two hours, and be consistent about when and where you work. Let yourself work longer if you want to, but don't ever work fewer hours than you've planned.

Don't allow interruptions during your studio time, and don't answer the phone, at least for the first couple of months that you work. Thinking time can count as studio time when you use this approach, but try to think in silence. Turn off the radio, the TV. Work in silence, at first, especially when you're starting a piece. (I make an exception for foreign choral music, for some unexplored reason.)

Whether you're overscheduled or relatively unburdened, accept the fact that finding time for art will be a struggle at times. When your job doesn't present obstacles, the rest of your life will, and when your life doesn't present obstacles, you'll probably invent some. The challenge will always be to outfox that inertia and make the art, anyway.

Even that scant two hours a week will add up fast, and pretty soon you'll get somewhere. You'll like it there!

## Space

Stories of how various artists have found space in which to make art are scattered throughout the book; that's because it's impossible to separate from the rest of your life the issue of where you make art. In addition, it's not a decision that is only made once, then forgotten.

As an artist's needs and circumstances change, so will his or her work space. An inescapable requirement, work space is a subject that's worth examining in some depth.

How did some artists first start to find space in which to work after leaving school? One man remembers taking a job at a bank. He says, "I didn't have a studio, just a little apartment. I built an easel against the wall and did these teeny little drawings. Desperate little drawings." Think of that next time you stand in line at the bank, staring at the tellers!

There are numerous living/working variations: Artists work in their small living spaces as this artist did, or they live in their large studios. Artists create a separate work space at home, or their studio is away from home. Any of these arrangements can work for the lifelong artist.

Some artists who make their art at home do so because they can't afford to work anyplace else. If you live in a large city where space is expensive, this could easily be the case. Others begin to work at home only when they have children; if they didn't make art at home, they wouldn't be able to do it at all. All artists who work at home need to establish certain ground rules pertaining to their time, their materials, and their work. When they take themselves and their work seriously, others will too.

Many artists who have worked both away from home and at home prefer the home studio. Not only does working at home allow artists to work erratic hours or to work in patched increments of time, it unites two parts of the artists' lives that otherwise would remain separate.

I had almost decided that the "home" or "away" studio decision was eventually gender-based when I read a local newspaper article that gave me a fresh perspective. The paper told the story of several male artists who had recently discovered the advantages and pleasures of making art at home. Each had previously worked in a generic loft-type studio, but each had decided to make the change. Maybe their children were grown, if they had children. Maybe expense was a factor. But each of them independently expressed the desire to integrate the disparate parts of his life; each wanted to make his life simpler and didn't mind if that meant working smaller. Work space can, in fact, be an expression of personal philosophy.

There are artists, on the other hand, who feel the need to make art away from home, whether they have children or not. These artists

might feel they can't concentrate at home. For other artists, the use of certain art materials makes it necessary for them to work away from home; size of work can be a determining factor, too.

There are artists who need the distance that exists between home and the studio. That distance provides a structure that helps them work. Sometimes the act of traveling to the studio enables artists to make a mental transition that prepares them for the work ahead.

Artists might feel there is a social advantage to keeping home and studio apart. Going to the studio can seem like "going to work" to the artist and to everyone else. And occasionally the people around artists need to be distanced; artists might be less likely to be interrupted when they work away from home.

Artists who often have studio visitors—curators and collectors—may feel they need to work away from home. Such visitors' confidence in the artist's "professionalism" could be bolstered by an impressive studio.

You can, however, make significant or insignificant art whether your studio is away from home or at home. Space certainly influences work—size, materials used, number of pieces worked on at a time, etc.—but it doesn't necessarily influence the quality of the work. Having a glorious work space might make it easier for you to make your best art, but it certainly won't ensure it.

Sometimes, in fact, when I visit an impressive space, I'm impressed with the space rather than the art. It's as though all the artist's energy has been swallowed creating the space. I find myself humming the children's song about the fireman: He has the right raincoat, hat, shoes, and he even reads the "Fireman's News," but he's no fireman.

Artists have to be flexible in so many ways. We have to be ready when change occurs, but we also have to make changes in our work space from time to time. For instance, I look forward to having a bigger studio some day, although I would still want to live where I work. But there are things I want to say, ways I want to work, that are impossible now.

If a teenager needs her own room, you may decide to give her your home studio and find a new place to work. If a family member loses a money job, you may need to work at home rather than away from home. Rethink your current situation: Do you really need a living room, for instance? Maybe that could be your new studio. Do you

have to purchase that new car? Perhaps those payments could go toward a remodeled work space instead. Might you live somewhere cheaper and "buy" work space (and time) with the money you save?

Sometimes we can be overly flexible, though. Don't compromise your needs merely out of habit. Don't "make do" with less than you need unless it's unavoidable. Years ago, I suddenly realized that if a meteorite fell onto my studio floor, I'd probably plant an indoor herb garden in the hole or rush out and price koi before I'd think of spending the money to repair the floor! One artist says, "It took me years to think that I deserved a real space. Really, I'd say eighteen to twenty years." Another says, "It's difficult. I mean, there are things that tend to come first, like getting the food." But she adds that she has "made it a point of giving my art more priority. A few years ago, I redid my studio, which felt really good. *I made it a space where I wanted to be.*"

Whatever your situation, make your studio a space where *you* want to be, and make the best work you can in that space. Respect yourself and your work—or your potential work—enough to fight for the best, most effective space you can get.

Is your studio the space you really need or is it what you've been told you need to be an artist? Does it suit not only your work but your feelings about how you want to live your life? When might a change in work space be necessary or possible? If you feel change is necessary but not possible, search for a way to keep working. For example, if you want to work on especially large paintings but haven't the room, you might be able to sublet part of another artist's studio for a limited period of time. If you need access to a kiln for a sectioned wall panel you've been planning, perhaps you could "rent" kiln space and expertise from a potter. Most art publications have "Space Wanted" sections in their classified ads; there's nothing to keep you from asking for whatever you need, however bizarre, to keep working.

Wherever you end up working, remember: It's not the space itself that's important, it's what you do in that space that really counts.

## Money

There are several opposing statements an artist can make about money. To begin with, it is certain that money will be a significant

issue for you as an artist. On the other hand, it will be an issue for you no matter what you decide to do. One artist even told me he now feels a person is apt to have the same level of success no matter what he or she chooses to do in life! But if you could use a special meter to measure the stress money worries can cause you, there's a good chance that the stress, at least, would be the same whether you were an artist or a stockbroker, even if the amounts of money worried about were vastly different. Stark poverty aside, I think the stress might come more from a person's attitude about money than from the money itself.

As an artist, you could also say you think it's easier for other artists to continue with their art than it is for you, since others must make more money; however, there will always be working artists who get by on less money than you do. You might feel that other artists don't face the financial demands you do, but of course there are lifelong artists with greater obligations.

Perhaps you are an artist without significant money problems: Your money job pays well, or you are supported by a spouse or partner, or you have independent financial resources. You might feel you're not suffering enough, somehow! But the quality of your art doesn't depend upon your misery level. There are rich artists making wonderful art and poor artists making lousy art. It might be difficult for a rich man to enter into the kingdom of heaven, but money can make it a lot easier to get into the studio. Did you know that Toulouse-Lautrec came from one of France's oldest noble families? That Monet had a platoon of gardeners working for him at Giverny?

Having money makes some things easier for an artist. You are likely to have more time to work, to buy better materials, to document your work more thoroughly, if you're not overly worried about money. On the other hand, money won't make you a better artist.

A common assumption about artists who lose their art is that they stop making art because they need to make more money. I don't think this is necessarily the whole truth. Even though making money may be an imperative, I don't think it's either the real reason most artists stop or a reason for any artist to stop making art completely. Of course, circumstances change. Many artists are still single when they finish school, or at least they're young enough not

to have many obligations, apart from repaying student loans. That situation usually doesn't last long. It's one thing to make financial decisions solely for yourself, but it's another to make decisions that directly influence the lives of people you love. It can easily seem necessary to make more money, more money. Suddenly there's never enough.

But how much money is enough money in contemporary society? The artists I've met over time have shared a similar attitude: They are willing to get by on less than others might be willing to, simply to continue making art. Even the artists who are "doing well" in their money jobs could probably be doing better were it not for the art. Still, the artists feel they have made a good bargain for themselves, and maybe even for the people they love, and they deserve some credit for this. And if this attitude seemingly affects the lives of family members adversely—well, a certain stubbornness or selfishness might have to be part of a lifelong artist's necessary armor.

Some artists evolve a compromise. One man says, "I've always been aware of the fact that you can't take money out of that particular situation—you know, like household money. So when I sold art, that money was set aside for when I wanted to buy a piece of work or get framing."

Daily, artists face the revealing issue of how they spend their money. One thing that shocked me in the first few years following art school was how hard it was for me to spend money on my art, even when the money was available. I was married, and though I had no children at the time, if I had access to an extra $100 I would find myself thinking, "We need new towels and sheets," even when I also needed everyday art supplies. Forget about wanting to try some new material, much less establish a satisfactory studio. I always made other plans for the money.

I did this to myself; I was even aware of it at the time. And after I had children, of course, there were dozens of additional ways to spend every dollar, and fewer of the ways were optional by then.

I didn't understand what made me do this, but it made me feel less of an artist. Was it my gender, my generation, my upbringing, a latent domesticity? I didn't know any other artists who were struggling with the same problem. An artist with similar early inclinations says, "Now I tend to spend more money on art materials than on clothes." Priorities change.

Some artists have always put a high priority on their art. One man says, "That's never been a problem for me. I am fortunate in that I always felt that spending money on the art is only investing in yourself."

Maybe a certain level of security—financial or emotional, depending on the artist—is necessary before a person can assume this attitude. The artists included in this book, for instance, come from extremely varied backgrounds, but none of them was destitute as a child. Art was a possibility for all of them. To rise to art from the seemingly hopeless poverty that is reality for so many children today—to rise to anything—presents a far greater challenge than any of us faced as children. There are artists among today's poorest children, but will we ever know them? Will they ever get the chance to make their art?

It should also be mentioned that the cuts in art education at so many public schools reduce the possibility of art for disadvantaged and middle-class children today. Many working artists first discovered art while in elementary school. Are children today getting the same chance we did to make art, to talk to artists, to visit museums? Children are losing something valuable, and so are we, when we allow art to be taken from them.

An artist often sabotages himself or herself by taking extreme positions about these three creative requirements. Such positions eventually make it difficult to continue to make art.

Time: You might say, "If I can't make art all day every day, it's not worth doing," or you could say, "I'll work when I really feel like it," even when more time is available to you. Instead, find a middle ground.

Space: You could say, "I'm going to wait until I have the ideal studio. My art deserves that," or you might say, "I'll just work over here in the corner; I won't make a mess." Instead, search for a space you can call your own, one where you can work regularly.

Money: You could say, "I need to make $40,000 a year before I can consider making art," "My art has to pay off, or I won't continue with it," or you might say, "I don't have to spend a dime on my art. I can make it out of bottlecaps and dew." Instead, discover how much money you honestly need—to live and to make your art—and work from there.

Every choice you make has a consequence. Finding the time in

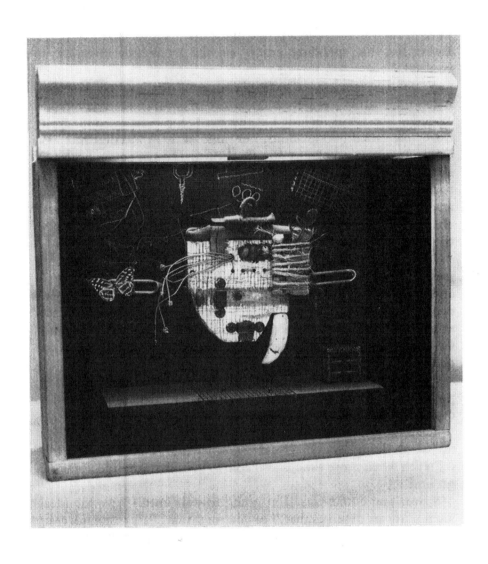

*Credo,* **Doug McClellan,** assemblage, 16" × 14" × 6". Photo by Wilfredo Q. Castaño.

your day for art, or taking the necessary space to work, or searching your wallet for the money to make art will mean that you are giving up something else. You might be surrendering some hours of relaxation, significant physical comforts, or a mental image of the way you should be living your life. As one artist says, "We have to work with our conditioning, break down those things we learned."

But if you ever come to the same realization that I once did, that you've been "living someone else's life," as I wrote in my journal, you'll realize that the price you pay for your creative requirements is the bargain of the century.

# *Recognizing Yourself as an Artist*

## Dealing with Internal Barriers

> "A review of my professional affairs is not too encouraging, and I do not know why, but I am nevertheless still hopeful ... But by way of consolation: It is valueless to paint premature things, what counts is to be a personality, or at least to become one."
> —Paul Klee

MY BROTHER ONCE TOLD me a story about a man who was being interviewed for a position by a grim-faced panel of experts. "Do you have a sense of humor?" the man was asked. "Yes, yes I do," he stammered. "All right then, tell us a joke," came the stony command.

This story horrified me, but for some reason I kept remembering it when I asked the following question of the artists in this book: "When did you truly start seeing yourself as an artist?" The first response was usually some version of, "I always knew it," but then the backpedaling would begin. This question didn't come from nowhere, of course, but I never thought to ask it, even of myself, the first ten years I was out of school.

After all, I had always known I was an artist, hadn't I? Like many, I had "known" this on some level since childhood, although in early childhood, it wasn't so much an awareness that I felt this way, as it was an unawareness that all others didn't see themselves as artists, too.

## Doubt

And then there I was, years later, degrees in hand. Now, I was smart enough to know that you don't have to have a degree to be an artist, and you don't have to be an artist to have a degree. But I was making art, after all; I was working. I was getting some recognition, and I wasn't telling any lies with my work. So wasn't I an artist? Why

**53**

was I backpedaling? Why was I stalled, was anything really missing? What was the barrier?

Sometimes I felt like an artist, and sometimes I didn't. Or rather, I felt that other artists were more certain about their art than I was about mine. No one ever seemed to voice any doubts in those days, and I thought that other artists' apparent sureness meant they were better artists than I. They were the *real* artists.

But things changed for me about ten years after I graduated from art school. Luckily, I read an interview about that time that meant a lot to me. I forget now who the artist being interviewed was, but he stated that he hadn't started making any significant art until he had been out of school for ten years, and furthermore, most of his colleagues shared the same experience.

Bless his heart for being so honest! It can take that long; it can take longer. His candor is an example of the type of extended helpful community for which artists need to search. It can save them. When one of us finds a way to break through the isolation in which most of us work, others benefit. Even knowing that one other artist struggled for ten years before he felt he had found his most authentic art gave me strength when I needed it.

"When did you truly start seeing yourself as an artist?" Of the artists I talked with, only one who had gone directly into art school said, "the summer after I left school." She got this feeling just through being alone, working on her art. I believe her; it can happen that way.

One other artist felt this certainty fairly early, but he had more external encouragement. LaMonte Westmoreland says, "After I graduated from college, Alonzo Davis gave me a show at Brockman Art Gallery. Most of the people that showed there I really admired, like Betye Saar, David Hammons, John Outterbridge. So that was it for me."

Sometimes an artist finishes school and finds he or she is equipped with the means to say almost anything, but simply isn't ready to say it—yet. And that's something that is hard for anyone to admit, especially someone young. Jerry Barrish tells the following story: "This critic said to me, 'Well, you know, you're a little old to be an independent filmmaker.' Most independent filmmakers are pretty young. I said, 'It's true, but I had nothing to say back when I was twenty years old.' What happens is you have a lot of filmmakers out

there who are really young, and they're energetic, and they might even be artistic, but they have nothing to say."

This doesn't stop them from saying it anyway—nor should it. The artist just has to try to find the momentum to work through this period, and it can be the loneliest feeling in the world. All of the work won't be bad, of course. In fact, a major challenge is for the praised young artist to keep listening to himself or herself rather than to the complimentary voice. This is the first of many times the artist needs to "choose something like a star," as Robert Frost put it, so that even if another voice is full of praise (or blame), the artist hears his or her own voice the clearest.

I think you are most apt to find your way to your truest art through this kind of work. If the process becomes too painful, if your dissatisfaction with your work becomes intolerable and you stop, it's awfully hard to start again.

It's hard, but it's still possible. If you stopped making art but you're ready to say something now, then now is the time to say it. In the long run, what does it matter when you first see yourself as an artist, as long as you get there eventually? Looking back on my children's earliest years, I see now that the timing of an artist's confident self-identity is a little like when a child learns to walk: If a child learns to walk at nine months, it's a big deal. It's remarkable. If a child is content to crawl at fourteen months, a parent can't help but envision him or her crawling off to work some day, briefcase dragging on the sidewalk . . .

But eventually the child walks, and, in the long run, who cares when it happens? Do you take pride in having been an early walker? Then it's time to update your résumé. Walking looms large for parents at the time, but really, so what? The important thing is that it does eventually happen.

You have to give art the chance to happen. You have to either keep working through the painful periods, which is rough, or you must find the strength to return to your art when you're ready. This can be even rougher. But in either case, don't be put off by the feeling that a real artist wouldn't have these doubts, these struggles. It's simply not true.

What are some of the other answers artists gave to my original question? One artist remembers only truly feeling like an artist the first time she was invited to an art colony; in fact, it was during her

drive to that colony. That's when it seemed real. She had been working for many years, and exhibiting, and selling, but it was this welcoming gesture by a noncommercial art community that finally did it for her.

Another artist truly saw herself as an artist only after her divorce. She says, "I made my art the center focus of my life then."

Doug McClellan says, "I'll give you a specific moment—four days after my twenty-eighth birthday!" He's only partly joking. He describes his earlier mixed feelings about art: "There was this great gulf between art, the thing I really wanted to do, and the reality I knew was out there, or thought I knew was out there." It was only after service in World War II when, as he puts it, "I had paid off the mortgage on being a middle-class kid in Pasadena, that I thought, 'OK, this is what I'm going to do.' " He felt like an artist then; he'd earned it.

In spite of all the external obstacles there are for artists, one of the biggest steps an artist takes is to honestly start seeing himself or herself as an artist. To finally see yourself this way is to trust your vision, because no matter how much work has preceded that moment, you are now thinking about work you have yet to make. The art doesn't exist at this point, so in a way, you are making a promise to your own future: You are promising that you now have something to say, and you will say it. It takes confidence to promise this, even to yourself, or especially to yourself. But once you have taken this step, you're a million miles past the barrier.

It's true that from this point on you'll experience a perpetual internal challenge to keep your work authentic—authentic to you, to your vision. But in a fundamental way, your creative experience will never again be as difficult. You'll never be that lonely again.

## Identity

I asked another question of the artists I interviewed and got an even more ambivalent response, which surprised me. The question was: "When did you really start presenting yourself to the world as an artist?"

I asked the question almost casually. This was an issue I had struggled with for some years, but I honestly didn't think other artists had had the same problem!

Hearing someone make the statement "I am an artist" had interested me since childhood. In spite of an innate if unfounded reverence for all adults, I had my doubts about some of the people I heard saying they were artists; they seemed more interested in being artistic than in making any art. Maybe it was my prim New England background, but I disliked that kind of overt artiness. The only art statement I distrusted more was, "I used to be an artist." Then what? "I used to be an artist, but I outgrew it"? "But then I got smart"? "But then I woke up one day, and the art was gone"?

Anyway, I loped along through the years, somewhat secure in my own art track, until I had children. The first of my two children was born five years after I graduated from art school. I only knew one other woman who'd even had a child, and I didn't see much of her.

In fact I didn't see much of anyone for a while. I was still trying to make art, but it was harder than ever; art isolation and baby isolation combined to make me a virtual hermit. Then when I did start seeing people again, they weren't artists. In fact, I don't think any of them even knew that's what I "really" was. And while I still saw myself as an artist, I couldn't bring myself to talk about my art with many people. It didn't seem as real any more. Maybe I thought that a person "really" was what she did, not what she said; maybe I didn't think I was working hard enough at my art; maybe I just didn't like the work I was doing. But another barrier had arisen. ("Like" is really the wrong word to use about art, incidentally. I think what matters more is the feeling you are making work that is right for you to make, now, rather than whether or not you find the work appealing.)

I tried to conserve my limited time and energy for art, but there were many demands on both. I found it curious that I suddenly had such trouble saying "no" to people when they asked for either time or energy. I felt I had to give some explanation if I refused them, and I was unwilling to do this. There was no way my explanation was going to be, "I can't. I'm an artist." I felt that response implied that I considered myself special, and that my time was more valuable than theirs was. I didn't feel that the art I was making then entitled me to make those claims.

Looking back, I see that one part of my problem was loneliness. I did need to be around other people, but apparently those people weren't going to be artists. The other part of the problem was that

my splintered life made it impossible for me to make the kind of art I needed to make, so I felt that I couldn't honestly say, "I'm an artist," although I still thought it was true, in my heart. Some circumstances eventually changed, and I changed some others, but it took a while for me to regain my confidence and my momentum.

Another artist recalls a devastating blow to her confidence at a particularly vulnerable time: "When I went to art school, the best compliment that they could give you was 'You paint like a man.' Well, imagine the effect of that on an eighteen-year-old woman. I'm not a man, so does that mean I'm not a good painter? Is it unfeminine to paint? You know, all these questions come in. And it was just the time when you're beginning to have your own sexual identity, and so forth. That was a very difficult passage."

I got some interesting replies to the two "identity" questions from the artists I interviewed, but I usually had to dig for the answers. My favorite exchange, and a representative one, is the following answer to the two combined questions:

Q: When did you start to truly see yourself as an artist?

A: Always, like in high school. So that is an old history with me.

Q: So you always saw yourself as an artist?

A: Yeah.

Q: Well, when people who don't know you say, "What do you do?" do you say "I'm an artist?"

A: Yeah. I say I'm an artist.

Q: How long have you done that?

A: (pause, then laugh) . . . About a year, now!

Another artist tells me, "I say I'm an art teacher. Then they might ask me, 'Do you work also?' and I say 'Yeah.' " This artist has a strong exhibition record, but he feels that, as he spends most of his time teaching, that's how he's going to identify himself, for now.

Sheba Sharrow has been an artist her entire adult life, but she answers the question this way: "In the beginning when people would ask me what I did, I would say, 'I'm a teacher.' Now I say I'm an artist, a painter. I've been saying this for about six years. I retired three years ago, so I said it for about three years when I was still teaching! In those three years I decided that I didn't want to be concerned with what the students were doing, I just wanted to do my own work. So that's when I really decided."

A teaching artist falls somewhere between these two points of

*The Prisoner,* **Sheba Sharrow,** mixed media on paper, 60″ × 45″. Photo by Steve Cicero.

*Torch,* **Jerry Ross Barrish,** assemblage/found objects, 14″ × 8″ × 6 1/4″. Photo by Mel Schockner.

view when he recalls, "I used to say to people, 'I'm teaching and painting.' Now I say, 'I'm a painter who also teaches.' "

Not all artists teach, of course. Jerry Barrish supports himself as a bail bondsman. He says, "I never felt like an artist when I was a filmmaker. When you make three films in fifteen years, and you never made a living at it, how do you say you're a filmmaker? I just felt like a filmmaker when I was at a film festival. It was pretty frustrating."

It wasn't the quality of his films or even the fact that he wasn't making a living from them that kept him from feeling like an artist; it was the limited amount of work he was able to do and the struggle he had getting that work shown. Now, he has no trouble saying, "I'm a sculptor." He doesn't make a living at sculpture, but he can do the work he wants, when he wants. That is the difference.

## *Shyness*

Sometimes the statement "I am an artist" is an implicit one. For example, when you work in public, you are "saying" you're an artist, and that can be hard for some people. Not only are you announcing your identity but, given human nature, you are inviting public scrutiny and comment.

Claire Henze recalls the following experience: "I wanted to be able to photograph in public, because inside I was a very shy person, and to have to go out and confront all this stuff was torture for me. But I wanted to do it. I made myself do it until I got good at it, and I realized later that it was actually a very masculine approach to the world."

I remember being commanded to draw chickens at the county fair when I was a student. I felt like I'd been asked to floss my teeth on television; such can be the combined self-consciousness and egotism of those early years. Everyone's watching! Unsolicited praise and criticism were equally painful to me. It was hard, and some people did stare, but the chickens didn't mind, so I tried not to either.

Maybe my teacher was trying to desensitize her students and make us "go public" with our art in a way few of us had before, or maybe she truly loved chickens. But consider LaMonte Westmoreland's teaching approach: "Right now I have my beginning students

at the high school go out every week to a gallery and write a critical report on an artist. They have to turn in eighteen reports by the end of the semester. My advanced students have to interview and videotape an artist, a gallery director, and a collector, so they know the whole realm of it."

This is an example of learning to be public about the business side of art, and that too is an important skill to learn. LaMonte is giving his students invaluable experience, because all of them are learning to say, "Here's who I am, and here's what I'm doing," and they are learning to say it early. Drawing even a champion chicken at the county fair would hold no terrors for these kids.

If you are having trouble truly acknowledging yourself as an artist, if you sense a barrier, it is important to identify and examine that barrier. In my own case, I didn't feel entitled to call myself an artist during those difficult years I described because I wasn't making enough art, and I didn't like the art I was making. I didn't realize that the important thing was that I was still involved with the process. That's what counted.

Another artist recalls a similar period, "It really took me about fifteen years to say, 'This is what they said I'm supposed to be doing, but this is not what I want to do.'"

## Confidence

Continuing to work in the studio when things aren't going well takes a kind of faith. The work that you do then is one of the things that builds inner strength, and that strength is what eventually enables an artist to have confidence both in personal identity as an artist and in artistic vision.

That faith is a resource the artist will need to call upon at intervals throughout life. About a year ago, I was going through a much briefer rough patch in the studio when I wrote a friend, ". . . still, I am drawing (some) and writing (some), kind of treading water in a way, until I tread into a current. Keeping busy in the studio anyway, and trying not to beat myself up too much." That was experience talking.

Experience doesn't make those periods easier, but it does inform an artist that the periods are survivable. So expect occasional setbacks. Don't lose your faith; keep on working. And don't lose

confidence in your artistic vision. Realize that these setbacks don't indicate your vision is false; rather, they are a normal—and ultimately, perhaps, productive—part of a creative life.

If you are having trouble thinking of yourself as a "real" artist or trusting your vision, examine your internal barriers. Keep the rest of the world out of it for now. Say to yourself, "I am an artist now, and I need—" whatever it is that you need to regain your momentum.

If the external world makes requests or demands of you that run counter to your needs, and that you can possibly avoid, do so heartlessly, and—here is the secret—without any elaborate explanation. For instance, if you have decided that what you need is time, and you have set aside that time, however meager, treat it like gold. If you have set aside money for your art, consider it spent. When someone suggests other ways of spending that money, simply say, "No, I can't afford it." You can't, believe me, and there's nothing shameful about that.

You don't have to be *totally* selfish to be an artist, but you do have to be selfish. Become creative with alternatives: If a friend calls with an invitation and you're working on your art, suggest another time right away. If your child's school calls and says, "You're not working, can you help us out?" say you are working, but you want to help in some other way. Pretty soon you'll have everyone trained, and then you'll actually have the chance to get some important work done.

Whatever your internal barriers are, be aware that even though your barriers bedevil you in their own particular ways other artists struggle too. And when your conquered doubts come creeping back occasionally, as they undoubtedly will, each time you'll be better able to face them.

Is it important for a person to be able to present himself or herself to the world as an artist? I think it is, if for no other reason than that it's good for the world. Let the world know that artists are out there! But I also think it's good for you, the artist. Hiding an important truth about yourself forces you to lead a double life, and that uses up valuable energy. It's bound to be bad for the art, too. You can use that energy and honesty in better ways. You can use it in your art.

When I talk about presenting yourself to the world as an artist, I'm not talking about clobbering people with the news. Don't

expect special attention, favors, or deference. Still, I think you can talk about art with people you meet, just as you would talk about any important part of your life. A good approach is to follow the advice given parents whose young children ask about sex: Simply respond to each question or comment separately, as it arises.

For instance, if someone says, "What do you do?" you can reply "I'm an artist." Period. Don't start to babble explanations, qualifications, or apologies; it's nothing to be ashamed of. If your questioner responds at all, it will probably be to say something about himself or herself, or some relative or acquaintance and that person's art. But if the next question is, "Really? What kind of art do you make?" then you can say "I'm a painter." And so on, one response at a time. This approach enables you to respect both your questioner and, most important, your art.

If you haven't done this before, choose your confidants carefully at first, and don't dissipate your energy by talking about work you've yet to do. Stick to the facts.

Perhaps a better question for me to have asked would have been, "When did you begin to feel *comfortable* presenting yourself to the world as an artist?" Expect it to take a while before you feel comfortable doing so. Don't be surprised if it takes time and practice. As I've pointed out, it's easiest to say "I'm an artist" when you're working well and you're happy with your work. But your artistic self-identity is central to your life; art is one of the best things about you. It is definitely one of the things that matters about you.

Who remembers now that Grünewald was a waterworks specialist? That Constable worked in a mill? That Turner was a mapmaker? That Degas studied law and Matisse practiced law? That van Gogh was a preacher? That Manet trained in the French navy? That Eakins was a much-criticized teacher? That Kollwitz was a doctor's wife? That Marin was an architectural draftsman? That David Smith was a factory worker?

Who cares?

As art takes on a bigger role in your life, your honest assessment of yourself as artist will come more and more easily to you, until it's second nature. And by then, no matter how many other things you do, you will be known as an artist first—by everyone.

And that's the way it should be.

# *Pride*

One thing that can shake this confidence for some artists is rejection. The rejection of a specific work or body of work is a commonplace experience for the artist. It comes from external sources; rejection itself is not an internal barrier for an artist, but his or her reaction to it can be. Rejection sometimes seems like an assault on self-esteem. It can seem personal. Even though rejection can be perceived as overall "attack," it's really just an individual response to the art. It is important to do what you can to prepare for rejection so that it won't interfere with your work or damage your confidence in your vision.

One way to prepare is to actively anticipate rejection. As LaMonte Westmoreland says, "I tell my students, 'Don't even worry about rejection, because if you're going to try for a juried show, or if you're sending stuff to a gallery and they don't like it, well, that's just part of the game, part of the system. Do not give up. No matter how much rejection, you just have to say to yourself, OK, that's the way it goes. It's just their misfortune.' "

Another artist says, "I feel that I know who I am, and if they don't, it's their hard luck." If you think this position is defensive, you're right! When you're required to take a consistently submissive attitude, you'd better have some defense planned.

"At the beginning, the rejections were excruciating, but I kept doing it anyway," says a sculptor. "You get by it." You do, and one thing that helps is to have lots of submissions out at any one time. That way, one specific rejection won't carry too much weight. If, on the other hand, you enter just one show, then wait and brood for the two months it takes for them to mail out the rejections, that rejection will seem more significant than it really is.

It's similar with commercial or academic gallery submissions. I found that these responses could be so slow, so erratic, that I evolved a positive response even to ultimate rejection: "Hurrah! I finally got my slides back! Now I can send them to—" whoever was next on the list. And I *always* had a list.

Stephanie Rowden takes a similar approach. "I try and keep it moving, so I get a slide sheet back and send it right back out. It's great, it's labeled, all ready to go out there. I have this sense that it's just very important to keep as many possibilities going at once."

*Relics #14,* **Claire Henze,** manipulated gelatin silver print, 14″ × 11″.
Photo by Claire Henze.

One of the most positive reactions to rejection I heard is the following: "I don't enter juried shows any more, but when I'm rejected by a gallery or museum, I'm in the perfect position. I thank them and ask if they know someone else who might be interested. *The important thing is to turn it around.*" This artist says that he feels this approach gives him back some power.

"I have this theory that I have to send out about ten things to get one thing, at least," says another artist. I think she is right. Increase your odds of acceptance by increasing your submissions.

How do you feel when you are rejected? I'm always surprised! Many artists share this feeling, although another common feeling is voiced by the artist who says, "I vacillate between feeling very surprised and then wondering whether they really know the deep dark truth about me and my work. I can go from one extreme to the other."

After my surprise dies down, which takes about three seconds, I get mad for a few minutes. My pride has been hurt. Then I usually go on to convince myself that the rejection was for the best in some way; I put it in the past. I try to remind myself that, after all, I'm having positive responses too. As Jerry Barrish says, "I think the more success you have, the easier it is to deal with rejection."

Here's another artist response that I love: "You know how these days there's the inner child? Well, I have the inner tantrum when I'm rejected! It usually lasts for about a day. I feel like, 'I'm not getting the support that I really want to have, and the world isn't taking good care of me.'" But she goes on to say, "I usually end up with a kind of resolve: 'They're not going to get in the way of my being able to do my work.' So rejection can be sort of a perverse shot in the arm."

Sometimes, though, rejection can get to be too much. It can become a barrier to your work. There are a number of ways this can happen. Occasionally, a cluster of rejections occurs. It's hard not to take this seeming consensus personally; it's as though someone is saying, "Gee, can't you take a hint? What's it going to take?" You start to worry that you're about to find out.

Every so often, it's the timing of a single rejection that can hurt. This is basically unpredictable and unavoidable. When you submit work for consideration, you have no way of knowing that two months or six months later you will be frantically trying to cope with

money problems, ill health, or a failing marriage when that letter comes. So one rejection can be devastating, and there's really no way to prepare for that one rejection, although you can try to keep your sense of perspective when it occurs.

Sometimes an artist arbitrarily invests a particular submission with symbolic importance: "If I can just get in this show, it will be a sign that I should continue." "If I can only get that gallery interested in my work, then things will take off." Try not to succumb to this kind of thinking. Good breaks happen, but counting on a specific external acceptance to cause something else good to happen is a false and losing game. You have to count on yourself. As Jerry Barrish puts it, "The days of the art galleries and the patrons are fewer and fewer. And now we find that we have to do it ourselves. We have to be our own patrons, and I think that really is much more challenging."

"Rejection is always a terribly difficult thing to take. I don't know any artist, however mature, who can take rejection easily," says Sheba Sharrow. If you get to the point where you feel that rejection has really become a barrier, where it is really affecting your work or other parts of your life, there are two approaches you can take. Either might be right for you. First, you can simply continue to submit work and trust that things will eventually change, that one day you'll make a connection with someone who "gets" your work.

Another approach is to pull back for a while. I think that sometimes a period of "art invalidism" can be healthful; take a rest cure. I don't mean that you should stop working, just that you might stop submitting work for a specific period of time. Refocus on your vision, and get your nerve back. Then start working again, and remember Harrison Storms's words when times get tough again: "If you can hang in there and sustain your energy, sustain your belief in yourself, then you've got a chance."

# *Strengthening Your Creative Resolve*

## Ten Achievable Qualities that Will Help You Continue to Make Art

> **"At that moment I grew aware of the mystery which urges men to create strange forms. And the creation appeared more extraordinary than the creators."**
> **—*Giorgio de Chirico***

**T**HERE ARE TEN characteristics that are necessary, in some degree, to an ongoing life in art. They are essential to those artists who are rediscovering their art, to those who are changing their art, or to those who simply want to continue working well, to keep on going.

To keep on going: The word "ongoing" implies movement, or momentum, and self-generated momentum is crucial to the enduring artist.

How will these ten qualities help you strengthen your creative resolve? First, take a closer look at the word "resolve." The primary definition that comes to mind has to do with deliberate choice, with will. You are deciding on art. But another definition is also interesting. In music, "resolve" is a progression from dissonance to consonance. Think of it this way: You are gathering together the scattered parts of your life and giving them a chance at harmony.

A third way to look at the word might occur only to a mystery lover, and that is to break "resolve" into re-solve. Re-solve: Something is not working, so you want to find a new solution. Your innate creativity is your greatest personal resource; resolve is what gives you the courage to make that creativity an important part of your everyday life. Art can be the solution to your mystery.

These ten characteristics are not secret merit badges that are mastered once and won. Rather, they are crucial issues that each artist struggles with throughout the course of his or her life. And you don't call on all of them equally at any one point in your life. For instance, when other responsibilities threaten to overtake your art, you need energy and concentration most. When you feel over-

71

whelmed by rejection, you may find endurance, self-reward, and perspective especially valuable. If you discover that success has its pressures too, you learn that open-mindedness and flexibility are called for. All ten characteristics are valuable, though, and all are achievable through individual awareness and effort.

I view my necessarily brief presentation of each of the qualities as a microcosm made up of just a few aspects of that characteristic. I combine my own feelings and thoughts with other artists' observations, and sometimes I throw in a little advice that might surprise you. Your own feelings, thoughts, and observations about any of the ten might be similar or very different. As you read, redefine each characteristic in terms of your own needs and experience, if necessary, but consider each of the ten a potential inner strength that will help you do what you want to do—make art.

The reader who can discover and strengthen these ten characteristics in himself or herself will experience a heightened ability both to make room for art and to maintain momentum as an artist. And sustained momentum is what enables vision to emerge.

## *Energy:* *Supplying Your Own Momentum*

It's easy to work when there's a show coming up or some other deadline to meet. Well, not easy, but you're likely to get the work done, even if it is at the last minute. In fact some people thrive on this kind of pressure. But what if there are no deadlines? What if no one at all notices whether you're working or not? What then?

Most artists, most of the time, work under these lonely conditions; they have learned to supply their own momentum. Most of the time there is no deadline; no more class assignments, no show coming up, no commission due, no studio visit planned. Most of the time there is no compelling, inescapable external reason to make art.

This is the everyday case for so many artists that there's almost no point in talking about the exceptions or wishing you were one of them. The artists who are able to keep working during these fallow periods, and even profit by them, have learned to cope with one of the biggest challenges in art.

Personal energy is an individual's inherent power, but the term implies a capacity for action. It takes energy to make art and, to put it another way, art takes energy from you. Jerry Barrish says, "I

don't feel any of the stress at all while I'm working. Afterwards is when I have real problems—muscular. Sometimes I'm in such pain when I finish a piece that I have to lie on the floor.''

While you may feel somehow revitalized by the creative process, it does take something away, especially when you start a piece. For this reason, it is important to be realistic about yourself and your time; too often we sabotage our own efforts. We say something like this: "Let's see . . . my biggest block of free time is at night, after dinner. I could work on art each night from eight to eleven instead of watching television or reading." Great idea on paper—I've thought of it myself—except who has the energy to start creative work when he or she is at the point of exhaustion? Try at least to *begin* important projects at a time when you have energy, not when you need it.

Another thing that is difficult for many of us to learn is to limit the number of things we do. There's so much pressure now to be everything, to do everything, that choosing not to can be hard. But it's essential to a life in art. This is a hard thing to hear, but if you don't limit activity, it's not likely you'll have the primary energy necessary for significant creative effort. For instance, if you have a marriage, children, a job, friends, and like to volunteer, hike, and go to the movies a lot, you'll have trouble maintaining artistic momentum.

It took me many years to be able to say, even to myself, "I can't make art and do a lot of other things too." Just that simple sentence! But acting on it meant saying no to some dispensable, if pleasurable, energy-consuming activities. The world didn't thank me for it either, and it won't thank you.

There are rewards, however. Another hard-won but commonly shared awareness soon developed: The more I made art, the less I felt like doing anything else!

Artists discover individual ways of supplying their own momentum. Some people are so heavily scheduled with unavoidable responsibilities that, as one artists puts it, "you learn to work when you have the time." Others find a variety of self-imposed deadlines to be useful. These can be on a very small scale. An artist might say, "I have to keep working until this cassette tape I'm listening to is finished" or "I won't stop until I've completed three sketches" or even "I cannot leave this room until an hour has passed."

I went through one such grim period a number of years ago when I was even marking the days off on the wall as I left my studio, as if I were in prison! I finally started to work again, out of boredom, I think. But I regained my momentum.

Some artists rise very early to work on their art. Their deadline comes when children wake up, when it's time to leave for their jobs. This approach takes discipline, but the rewards of solitude and time make it worthwhile to them.

On a larger scale, you may find yourself using a calendar deadline to motivate yourself to work on art. If you have school-age children, it is logical to view the end of the school year as a sort of deadline. When my children were younger I tried to work all year, but I found my most productive and least-interrupted period to be from January to May. I looked forward to that period of time and planned for it each year, as do many artists with children.

Sometimes a personal deadline approaches. Stephanie Rowden was planning her wedding when she told me, "I have the sense that there's a whole group of work that I really want to have finished before this wedding. These unfinished pieces are very much about my life right now—they seem like half a sentence. It somehow feels important to me to complete the sentence and then be able to start afresh."

A fake deadline can be useful in providing momentum too. If you've ever planned a party just so you'd clean up your apartment, you know what I'm talking about! Invite someone you respect to see your work, then work.

Occasionally, or maybe it's always, life itself is the deadline. Claire Henze has been living with cancer for many years. She says, "I know that when I've been ill, for some reason I've had tremendous creative energy. I think it's a sort of life-saving attempt through art."

It's not a question of finding merely one method, one trick, that will get you going again when you've run out of creative energy. It will be the ongoing challenge in your life to keep on working, and your methods will change with each new challenge. But being able to do this for yourself means that you are not simply reacting in your art—reacting to externals. You are acting.

It's natural to feel a little panicky during periods of artistic isolation, and we long for those exciting external influences during

such times. But these are the very times that provide the opportunity for thoughtful change and lead you closer to your authentic art.

Learn to keep working during fallow time, and recognize this time as a creative necessity for yourself as an artist. Recognize such time as the luxury it is.

## *Perseverance:* *Overcoming Real-Life Obstacles*

"I didn't have a job or even a place to live yet, really. My boyfriend had just dumped me and it was terrible, and yet it was a creative time. I felt very awake and energized. I felt excited about making art." An artist is describing an earlier period in her life, when she was just out of college. Her resilience in the face of her new life is apparent but not surprising; after all, most young people seem to have a natural resilience. It's almost as though their shock absorbers haven't worn down much—yet.

But something of that resilience stays with us as we get older. It certainly has to stay with those among us who persevere in keeping art a central part of our lives. I'm not sure whether that resilience makes the art possible or art makes the resilience possible, but it hardly matters. The important thing is for each of us to learn to cultivate this quality, and in fact to strengthen it. You want your shock absorbers to get even stronger as the years pass. You want to get tougher, in a way, at the same time that you're becoming more sensitive to everything around you.

It's not being pessimistic to try somehow emotionally to prepare for the real-life obstacles that are sure to occur; rather, it's a positive thing to do. You want to be relaxed but prepared for anything that might knock you off balance as you persevere with your art.

I think this is, in fact, an optimistic approach: You're keeping your eye on the art, not on the problems. And this optimism is both a crucial and natural part of your character. After all, making art is an inherently optimistic thing to do.

But surprise is the one thing experience prepares us for. We usually worry in advance about the wrong things, overworry about unavoidable things, and completely miss the next thing waiting to pounce. So there's no point in trying to anticipate the exact obstacles that will interfere with art. We can't, thank goodness.

There are so many obstacles that can come between us and our art

that it's hard to know which ones to write about. Money, health, emotional conflict; the obstacles are different for each of us, and they will change throughout a lifetime. Some of these obstacles are included elsewhere in the book.

But there are two potential obstacles I'll write about here. Many artists have faced them in different ways and found them to be manageable, or at least endurable. One is children. Children are a blessing, right? Certainly. But having children knocks many of us off creative balance, no matter how much we've longed for a family. I remember an artist telling me, "Before we had children we were hippies. Afterwards we were just poor." If you are one of a couple, suddenly it's not just the two of you. With children, every choice you make takes on a dimension that was impossible to anticipate.

Even apart from that, the gap can be wide between our expectation and the reality of what it will be like to be a parent and artist. Claire Henze, codirector of a gallery when her son was born, says, "I thought I could take the baby to work and he would sleep under the desk, which was a far cry from reality." Recalls another artist, "I was under the delusion that I could just keep doing it—that time would be broken up, but you could just put the kid in your backpack or the playpen and you'd keep working."

Sometimes it works for a couple of months. I remember painting while holding a newborn in one arm and thinking, a little desperately, "I'm managing! I'm managing!" But even this strained period can't last long. A baby soon develops ideas of his or her own, and being a cooperative little art accessory isn't going to be one of them.

Children grow up, but this painful period can seem endless. The feeling of doing a half-good job at both parenting and art is intolerable to some. "I'm going to end up being both a lousy artist and a lousy mother. What am I going to do?" one artist remembered saying to herself.

Virginia Cartwright decided to stop making art temporarily and "redirect that creative energy into something that had to do with art. I wanted something that I could pick up for just half an hour at a time." She spent a year of half-hours designing and producing a ceramics tool that, as she put it, "got me through that period."

Other artists feel drawn to this kind of solution but also feel unable to give up their art, even for a while. They barter for or buy what babysitting help they can.

They also readjust their expectations. Claire Henze remembers thinking, "Well, don't expect anything, and if something happens today, that will be remarkable." She found it hard to stay in this "no expectancy phase" for long but comforted herself by reading about other artists who'd raised children and somehow kept on working, or went back to it; the photographer Imogene Cunningham was her particular beacon. Another woman recalls flatly, "I painted when the children were taking a nap."

Most of us patch together some combination of these approaches, and time passes. That's what I did; my motto might have been "A babysitter is cheaper than a psychiatrist any day," but I also found a good cooperative nursery school and developed work on which I could spend half an hour at a time. And sometimes I still had to stop for a while.

Like most who persevered with their art while parenting, memories of those early childhood years remain vivid for me. It's over, but as one woman puts it, "It's never going to pass."

Finding studio space can also require perseverance, whether you work at home or away from home. The woman who painted while her children napped recalls, "I appropriated the dining room or the basement for my studio. My husband objected to it, but I did it anyway."

The whole issue of where to work is interesting and affects both your work and your life, but it will be dealt with here only in terms of overcoming specific obstacles. Family opposition to studio requirements can be an obstacle. Studio size can be another obstacle; it certainly affects the way you work. But having a big studio isn't everything. Virginia Cartwright recalls, "Someone introduced me to a female potter in Tokyo and she had this little place, like eight by eight feet. It was all studio, but she stored clay under the floor boards. She had it all worked out so she could do it." I'm sure she's still doing it.

Sheba Sharrow says, "Space is important, but I remember Mitchell Siporin. He worked on the WPA. And when I saw the little closet that he called a studio! But it was his own room. He did all of his wonderful and beautiful paintings in that little room."

She concludes, "I think it is most important to have a space that is totally occupied by you alone as an artist." This holds true even if it is a very small space. Sometimes it makes more sense to burrow in

a smaller space for the long run than to spend six glorious months in a loft praying for a miracle. The lower your overhead, the longer you're likely to be able to persevere with your art. Some artists feel they need their studio space to be away from home, and they are willing to sacrifice to make this happen. One describes his studio: "It is very inexpensive because it has no running water, and it has no phone. It's cold. It has no toilet. You have to find some restaurant and ask if they'll let you use their bathroom." Sacrificing on his living arrangements is what makes having the studio possible. This isn't someone just out of art school, either—far from it.

Even the temporary loss of a studio served one artist well: "I had back surgery six years ago. I was in the hospital for a month and in a walking cast for half a year. I had been making fairly large installations, and having this surgery was a crisis. I didn't have a studio for about a year. But I would say that it caused me to get a real bird's eye view of my life and where my energy was going."

Some obstacles are really ordeals, and they stink. They simply have to be endured, and there's no point in trying to turn them into cheery little life lessons. But even these . . .

Sheba Sharrow puts it beautifully when she says, "I think that only after you've been through a lot of trials in your own life do you finally come down to finding what your inner voice is."

Use the things that happen to you. Triumph over the obstacles every way you can, especially through your art.

## *Concentration:* *Focusing on Your Art*

"I'm just beginning to understand what it means to be able to concentrate," says an artist in his mid-forties. Of course he's spent his life focusing attention on thousands of individual tasks and abstractions, but concentrating on art is different. It demands more, and there's often no immediate measurable payoff.

There are physical tasks we master through concentration—tying our shoes, serving a tennis ball, or driving a car—where the rewards are obvious. Then there are concepts we struggle to master, such as arithmetic or outer space, for example. These too require concentration, and if the reward isn't practical knowledge, such as you might gain through math, at least you passed the quiz that Friday.

We concentrate on the book we're reading. Maybe it's entertain-

ing, or it might contain information we need, or perhaps the escape it provides relieves anxiety. But there's a payoff. We listen hard to what other people say, even when our thoughts teem with a hundred other things: We listen out of a need for human connection, or we're lonely, or we want to be listened to in turn, or we truly care about the person speaking. Sometimes we're even interested in what he or she is saying! But the attention we pay is rewarded.

Art requires different kinds of concentration, and that concentration is not rewarded in conventional ways. Being able to keep an image in your head in spite of distractions or broken time can be hard. Everyone has had times when they've had to fight to reel in their thoughts, when they've had to struggle just to read a paragraph and understand it. I remember a time when my children were very young; at one point I couldn't even finish a magazine article, much less draw. Once I became aware of this, I consciously forced myself to finish small intellectual tasks, to come back to them again and again until they were mastered: reading, listening to music, even thinking about something. It was a given that attention would be shattered. The important thing was to return to the subject.

This stubborn approach lacks poetry, but it works—with art, too. The struggle may show on the piece you force (although it may not!), but the reward isn't meant to be the art. The reward is your concentration and the confidence it has helped build. And your strengthened focus will show up in the next piece on which you work.

This approach can also be useful under other art circumstances. For instance, if there has been a break of some months (or years) in your art, for whatever reason, you will need to rebuild your ability to concentrate, to focus. Or sometimes you'll need to have the courage to stop work suddenly and refocus on what it is you—*you*—are really trying to do. This can be even harder.

Sometimes concentration enables a working artist to make a leap that enriches future work. A painter/teacher says, "I once borrowed a skull from the biology department and did about sixty studies so I could draw it by heart." Another artist retaught herself perspective during a period in which she was unable to work on her usual art.

Anatomy and perspective are specific skills that can, to some extent, be mastered. But a lot of what happens in the studio is intuitive. Is it contradictory to try to concentrate on intuition?

It's not contradictory, it's essential. For some reason, most nonartists ask "How long did that take?" when they look at a work of art. That's usually an unanswerable question. Every artist I've spoken with stresses that he or she rarely stops thinking about the art. Each is always open to it; it's always in his or her head. A sculptor accumulates assorted objects, scarcely knowing their ultimate use. Her intuition is at work. "It's so slow for me. Some of these things I've had for five, seven years in my studio. It's taken me a long time to figure out what to do with them."

This seductive preoccupation with art can be a distraction, but it also enriches the artist's life. In fact it's one of the things that makes quick focus or intuition possible once that artist is in the studio. The art is already in his or her head, so that artist is ready to work.

Are there innate characteristics that make concentration easier for some people than others? Artists might say, "I'm very structured," or "I'm pretty ritualistic," but not always. One artist says his secret is that he's "a very self-abusive type"! Many other working artists seem to be self-abusive only in that they feel they should be working even longer and harder. They imagine that all other artists work harder than they themselves do.

But anyone can improve concentration skills if it seems important, and art makes doing this worthwhile. There are palpable rewards for strengthening this characteristic. One painter notes that his work has accelerated as he has gotten older. His focus is quicker, cleaner. When asked (not too tactfully) if this might be because he has less time left in life, he agrees, then says, "Also, my ideas are beginning to come together. What's begun to develop is a methodology for approaching complex work: You're trying to put together ideas, feelings, and technique, and you're trying to get them all to work together for a long enough period of time to where you have a product." He adds, "Most of the time one is ahead of the other, or they're out of sync. It's not very efficient."

The process of making art is not very efficient. But the concentration it takes! A neurosurgeon once told me, "It's amazing what you can do. I could never do it." I gazed at her in astonishment, "You just finished fourteen hours of microsurgery!" But art takes a different kind of concentration. It's on a different level.

When one artist refers to his attempt to keep two-dimensional space, three-dimensional space, and numerous philosophical ques-

*Schroon River/2,* **Sally Warner,** charcoal on paper, 6" × 6". Photo by Art Works.

tions in his head while he works on his art (and teaches, and lives the rest of his life), I picture a juggler with three chain saws in the air who is simultaneously trying to keep his footing on a huge rubber ball. And usually no one is in the audience. As he puts it, "It can play havoc with your confidence."

Confidence, or nerve, is an important factor in being able to concentrate long enough to make art, and that confidence has to be internal. It takes confidence to concentrate on art, and concentrating on art will build confidence. It's reciprocal.

Virginia Cartwright recalls the supposedly-free sixties and seventies: "I was making my own path. Everyone else went away from function—away, away, away. And I was staying with function." Her focus was on her own vision.

I went through something similar when I came to the painful realization that I wanted to draw rather than paint; not just that, I wanted to draw small; and not just that, I wanted to draw small landscapes! Where did this come from? Certainly not from my art education or any prevailing winds. For years after that, I thought of myself as "the revisionist swine." But when you're talking about trying to spend a lifetime with your art, no other approach than focusing on your own vision is worthwhile, or even possible.

## *Endurance:* *Sitting Loose*

When I was in art school, a teacher was famous there for no longer making art. He was supposed to be a wonderful teacher. I wasn't in his class so I never heard his explanation for this renunciation, but it was rumored (somewhat admiringly) to be because he could no longer stomach the dishonesty, hypocrisy, and downright silliness of the "art world." It all seemed romantically plausible at the time, but now I think it's more likely that he simply couldn't tolerate the pain involved in trying to have his art be part of the world.

Another artist recalls a dark period in her life: "I got discouraged, and I stopped working for a while. I seriously thought about stopping forever. I thought, 'This is not worth all the time and energy I put in. And who cares, anyway? I might as well be in the corner reading a book.' "

She soon got past this point; the teacher never did, as far as I know. But this period of stark awareness—that no one cares—hits

many artists hard. It's a very uncomfortable realization, and it often comes soon after the artist is out of school, on his or her own. It comes early. Add to this awareness the further discomforts of year-in, year-out struggle and rejection, and you might wonder why anyone keeps on making art at all.

No one likes physical discomfort, and no one likes emotional discomfort either. Our contemporary response to either is to end it, one way or another, and as soon as possible. Headache? Take a pill. Depressed? Get a prescription. Fed up? Get a divorce. Sometimes the pill, prescription, or divorce is the right answer, but too often we don't take the time to find that out for sure; we can't tolerate the period of discomfort long enough. "I don't even care anymore. I just want it to be over," we say.

A friend of mine took a different approach when faced with domestic problems so stressful that most other people would have scurried for cover. She sums up her attitude with the Quaker expression "sit loose." Sit loose—don't act, wait. Be alert, stay as relaxed as possible, and remain aware of what is happening. Endure. Get comfortable with being a little uncomfortable for a while, but wait. It wasn't the fashionable approach, let's put it that way—but it worked.

It works with art, too. Virtually every enduring artist can tell of a trying time when he or she merely "went through the motions" in the studio. Sometimes, however, going through those motions is sufficient activity to move the artist to another, more productive place. So even though sitting loose might seem like an overly passive approach to a bad patch in the studio, it can be effective. Occasionally acting as though nothing is wrong—even acting like an artist when you feel anything but—is action enough.

Even if you're not a natural stoic, endurance is still a worthwhile quality for any artist to cultivate. The struggle and rejection that virtually all artists experience in waves throughout their creative lives try the strongest of us, and we need all the strength we can muster. Luckily, endurance gets easier with experience.

But what is the difference between becoming experienced and becoming hardened? What is the difference between endurance and masochism? Is there any healthy purpose in tolerating what can feel like an intolerable situation? Yes, if the result is your growth as an artist.

Experience teaches us things about art, things that will help us build the endurance necessary to tolerate discomfort and continue making art. For instance, we discover that other artists go through similar difficulties, even if it seems to us that our struggles are unique. I hope this book helps serve that purpose, too. One woman looks back on a life punctuated by children, divorce, and illness and compares herself to artists whose progress appears steady and seamless. She says, "I feel like I reached a peak and sort of disappeared, and reached another peak and disappeared. I have an image that this doesn't happen to other people." She likens other artists' lives to escalator rides, whereas she feels she's been "on a broken elevator, where you get stuck between floors." But she's not alone, and she realizes it more as time goes by. Seek out other artists, and talk with them, honestly.

Experience also teaches us that even the darkest periods pass. Artists remember bad times in their lives and say, "I was desperate. I was depressed, as you can imagine. Everything looked hopeless . . ." and "It felt like I hit bottom a bunch of times." But things got better for these artists.

Occasionally we discover that sometimes things stay tough, and making art still can be worth it. One artist confides, "The years roll on and it gets—it gets more difficult with each year. Especially if there's not much success." This artist concludes, "You have to sustain the enthusiasm and the willingness to learn. I don't know, I think it's got to come from a deep fundamental belief that you're somehow contributing." Spend some time thinking about what it is you have to contribute through your art.

Not much success, lots of rejection. Artists' different ways of coping with—and even using—rejection were explored in chapter 4, but experience enables some artists to sit loose when their work is criticized or rejected. It can depend on the work, though. Jerry Barrish, filmmaker and sculptor, experiences rejection differently in these two areas. He says, "I love my movies, but when no one else does, it really is very painful. 'If you don't like my baby, you don't like me.' That's how I feel. I'm really sensitive about my baby." The stakes are so high with a film; it represents several years' work and a pile of money, too.

It's easier for him as a sculptor. He makes his sculpture by himself, for himself. And if he chooses to send it out into the world and it

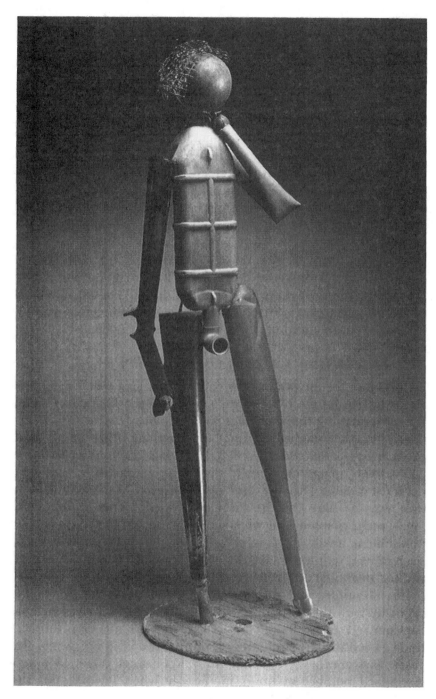

*David,* **Jerry Ross Barrish,** assemblage/found objects, 48″ × 18″ ×
10″. Photo by Mel Schockner.

meets with rejection—well, as he puts it, "I'm disappointed, but I know that I can't be in every show that I enter." That's simple pragmatism. He concludes that when positive things start to happen, negative experiences seem less important. And positive things won't happen unless you try for them, unless you at least try to put yourself out in the world. Give the world a chance.

Was the teacher who had stopped making art a happy man? I don't know, but he didn't appear to be. Struggle and rejection don't have to devastate an artist; there can be something in you that these negative things rarely touch. And endurance can be part of your strength.

A happier artist is the one who describes her attitude the following way: "I say to myself, 'This is what I'm doing; this is what I believe in; this is what I really want to be doing.' For me, it's always such a struggle to get to that point, and I have a feeling that it always will be." Probably so, but it will be the right struggle.

## *Self-Discipline:*  *Carrying Out Your Plan*

"A problem for me is not only to begin an idea that I'm excited about but really see it through," says an artist. She's not alone. Seeing something through takes self-discipline.

Self-discipline might be defined as something other people have, or seem to—people who learn Italian while commuting to work; people who appear perpetually sleek and composed; people who never eat dessert. The very term "self-discipline" can seem negative in a way. I think it's the "discipline" part: That word brings punishment to mind. But when we're talking about art, there is no punishment involved, merely "self," in the most positive sense. Each of us is trying to make the invisible visible with his or her art, and self-discipline can help each of us carry out that plan.

It's interesting that many working artists equate self-discipline primarily with their studio schedule, and find themselves lacking. Says one, "I am so loosely structured that it's not even funny. I think I need to start structuring it more tightly." After twenty-five years. Says another, "I would really like to get down to a very disciplined number of hours in the day when I work, and I'm getting there." After forty years.

Obviously these people are already doing something right—

*Beyond the Wall #14,* **Harrison Storms,** acrylic on masonite, 64" × 48". Photo by Harrison Storms.

probably *just* right, for them—to have kept working so long in the first place, but it's also obvious that even with experience, we often measure ourselves against some faceless ideal artist.

These real artists are already successes in what I feel is the heart of real self-discipline in art: Each is "trying to stay connected to the deeper sense of why I make the work," as another artist puts it. That connection isn't just made once; each artist struggles constantly to keep it. Harrison Storms says, "It's almost like a contest in a way, when you sustain it. I have a real clear idea in my mind of what those structures in my work represent, what the figures are trying to do. But can I sustain the energy?"

His primary struggle takes place in the studio. Yes, it does eventually boil down to actually doing the work. Think about self-discipline in a broader way. Think about it as a characteristic that a) is valuable to each of us if he or she wants to make art, and b) is an innate quality that each of us can learn to strengthen.

Sometimes it can take self-discipline *not* to work—that is, to stop and think for a while. An artist recalls an unpleasant period that followed a major rejection: "What I really needed was to trust my own development. I needed the time to be with myself quietly, gathering information from the library, gathering images, drawing, and really kind of learning for myself. Not that that is always the case."

Taking this time away from action can be hard, and recognizing when it is necessary and when not can be tricky; for years after college I was haunted by a character from Flaubert named Pellerin: "Pellerin used to read every book on aesthetics. . . . He had surrounded himself with every imaginable accessory—drawings, casts, models . . . he blamed the weather, his nerves, the studio . . . he had so far, at fifty, produced nothing but unfinished sketches."[4] Pellerin couldn't step into the studio and shut the door, which is what we all have to do sooner or later.

Another artist I spoke with was similarly haunted, but by a character in a movie. Here is how he describes him: "There was this artist, an old guy. He didn't have much going for him, but he had one nice suit. These younger people took him to parties, and he could talk art, but I don't think he really did much art. He just kind of said he was an artist. I was frightened to death that I was going to end up like that guy."

He didn't, but I think many of us have such a cautionary ghost lodged somewhere in our minds, and that ghost can serve a useful purpose. We don't want to "end up like that guy," so at some point each enduring artist finds the courage—and self-discipline—to step into the studio and shut the door. We stop preparing and start making.

When you are ready to do this, whether you're returning to your art after a long absence or you're "just" making a change in your ongoing art or the way you feel about that art, one useful piece of advice may be: Don't talk about it. Making art is physical. Talking about something isn't the same as doing it, although we often confuse the two. "I'm going to work on my art at least four hours a day! I'm going to make fifty paintings this year!" we say to everyone, already elated—and a little exhausted. Time for a nap.

I think talking about some physical thing you're planning to do takes energy away from the act, and you're going to need all your energy. So think once more of the "self" in self-discipline, and keep a few secrets. You can talk later.

All that's left is to start working, to start carrying out your plan. You don't need to have everything figured out in advance to do this, but you do have to begin somewhere. Set up a reasonable work schedule, and stick to it. Privately. Don't worry about inspiration; inspiration comes while you're working.

And if it doesn't? Keep on working, even if by rote. If you've spent enough time thinking about why you're making art, what it is you want to say, and how you want to say it, the inspiration problem won't last for long, if it really is a problem. Virginia Cartwright reflects, "There will be a piece that turned out well, and I'll remember back to the day I made it when I really didn't think it worked, and I said to myself 'Just give it another hour. Just plod along, one foot in front of the other.' And then six months later, I see it's a beautiful piece."

That kind of plodding is occasionally necessary, but I used to think that it would always show up somehow in the finished work, which would make the plodding counterproductive. Sometimes it is apparent, at least to you; you look at the piece, and all you can see is "struggle." But often the plodding doesn't show up at all. And even if it does show up, at least you struggled through the problem; you kept on working.

Cultivate self-discipline by staying connected to the reason you are making art. Be self-disciplined about what you make: Carry out your plan. And be self-disciplined about when you work. If you're disciplined in these three areas, then you're more likely to be free, to be flexible, where and when it counts—in the studio, while you're working.

## *Flexibility:* Changing Course

I'm disciplined in my approach to art, and I'm flexible in my approach to swimming. In fact, I'm so flexible about swimming three times a week that I haven't done it in nine months!

That's the trouble with being flexible before you do something, being flexible in approach: You can flex yourself right into avoiding the thing. If I were disciplined enough to swim regularly, I could be flexible once I was in the pool by varying strokes, talking with other swimmers if I felt like it, perhaps looking forward to a few minutes in the hot tub afterwards. But at least I'd be in the water.

You want to be in the studio. (I use the term "in the studio" to cover many working possibilities—a loft, a converted garage, a spare room. What I really mean is that you're alone—finally!—with your art.) You're ready to work, to make art.

In a way, you can look at making art as making a series of choices, one after the other. That in itself takes flexibility. But sometimes circumstance forces us into choosing a certain art material, or it forces us to work one way rather than another. And we need flexibility to adapt.

For instance, Sheba Sharrow worked with oil paints for years, and then one day "the oil paint mediums started giving me terrible headaches." It can happen very quickly; she had to switch to acrylics, but she now prefers them.

My own favorite series of drawings, the drawings I've been working on the longest, is a group of very small landscapes. It was revolutionary enough for me to work this small, after going to art school in the big-and-loose sixties and early seventies, but I really started on them because it was the only size paper with which I could travel. I soon evolved a format that satisfied me aesthetically, but it all started with paper size.

Occasionally things happen in our lives that affect work habits.

For example, Stephanie Rowden was doubly challenged following her back surgery: "I'm gradually moving toward being able to make things that are smaller. I still have physical problems, and that means I'm somewhat dependent while I'm doing a big project. I need to ask for help, and it's very hard for me to do that." Reevaluation has caused some of her work to change, and when she still wants to work big, she is learning to ask for help when she needs it.

Claire Henze found that an external challenge, chemotherapy, caused her subject matter to change. Describing her earlier work as "social landscape," she recalls the fatigue she experienced and the changes she made after undergoing a round of chemotherapy: "I thought, 'Well, I can't do that now, because I'm tired and I can't carry the heavy equipment. But I can do something about the life around me.' So I started using my kids as subjects, and whatever else was going on." This was a revolution for her, since domestic life was not considered "serious" subject matter in art then, while street life was.

An artist I spoke with describes her struggle to "stay connected to that experience of discovery," and I think that is a good definition of flexibility in the studio. The experience of discovery is what makes changing course a pleasurable thing to do, all other considerations aside. With discovery there is surprise, and surprise keeps us working, for years. At seventy, artist Richard Deibenkorn said, "After all these years my own work still surprises me. That's the real reward."[5]

Of course surprises happen in art whether we want them to or not, but very often they turn out to be good for the work; the art term "happy accident" describes that phenomenon. Some artists not only take advantage of this when it happens, they count on it. They make it happen. Says Virginia Cartwright, "Well, with the colored clay, you can't always tell what the colors are going to be. It's so hard to imagine—you can't be very specific." And so she's often surprised when she opens the kiln door.

In many of my own drawings I use charcoal powder, and there is a built-in element of surprise with that material. I'm forced to be flexible with the result. I know the idea of "built-in surprise" seems contradictory; I'm reminded of the old Inspector Clouseau movies in which the inspector's servant would shriek and leap out at him from a different hiding place each night. I guess it served to keep Inspector Clouseau alert, and some restrained version of that can be useful to artists, too!

*Teapot,* **Virginia Cartwright,** unglazed clay with inlaid colored clays,
7" × 9" × 4". Photo by Lana Wilson.

Harrison Storms says, "I like the process of applying the paint the way a laborer would and the fact that you can so quickly and violently get rid of something if you hate it. You can just scratch it out, scrape it out. Plaster over it, paint over it." He's creating his own surprises.

Artists often describe the experience of returning to uncompleted work and seeing it in a new way. They leave some things alone, though they'd planned further work. They decide to rework areas they'd thought were finished. This is one reason I usually find it valuable to work on three or four pieces at once; it forces me to come back to each work in progress with "new eyes." So sometimes a little distance, even if it's self-enforced, can be valuable to an artist, if the artist maintains a flexible attitude.

Grace Paley wrote a wonderful book called *Enormous Changes at the Last Minute*. I often think of this title in the studio. Many artists use this approach with their art. Well, it's more of an attitude than an approach. These artists are capable of suddenly surprising themselves, whether they decide impulsively to cut up a painting to create a collage or turn a collage sideways and start reworking it. Says one artist, "I make changes and break pieces up. In the beginning I never did that. I just did the piece and that was that. Now I keep trying to improve."

If you find that you *always* make drastic changes to your almost-completed work or you consistently destroy work in progress, or if you often destroy finished pieces, you probably should reconsider your plan, or make a new plan.

Many artists talk about feeling a sense of wonder as they work, and that feeling can be even better than surprise. It, too, can make flexibility worthwhile. Jerry Barrish says, "What I try to do is find the magic—there's one magic piece that triggers the whole thing, that says what it's going to be. And then the other pieces follow." Another artist talks about "those phases where the project starts to reveal itself and become something different." Magic, revelation. Stay flexible enough to listen to your work, to let it astonish you. You won't be able to describe this feeling coherently to many others, so don't try. The feeling belongs to you.

An artist tells me that a central challenge in her art is maintaining "the ability to leave my expectations behind." I feel that this is an important thing for any artist to be able to do. Certainly some

aspects of art are controlled, planned; after all, you're there in the studio with your art materials around you, you're not singing hearty songs at some ski lodge. Your preparations aren't random acts, but once you start to work . . .

"There is a certain kind of structure I work with," says an artist, "but it's almost as though I chew through that, digest it, whatever. I let it go, and then I can allow myself to think more freely about it." Freedom—while you're working! When you're alone with your art, you're probably the freest, the most flexible you can ever be. Your art gives you that experience. Take it and run.

## Stubbornness: *Defining Yourself*

"What do I call myself? If I'm trying to get credit, it's 'office manager,' " says Stephanie Rowden.

This is a capitalist country, and when you decide you are an artist in a capitalist country, you have stepped off the track, at least mentally. But people in today's society are usually defined by the way they make money, so labeling problems—if not identity problems—can begin.

If you are an artist and you're trying to get credit, you'll probably define yourself by your money job. At that job you might not even mention your art, though you consider it your real work. But if you know that what is really being asked is, "Are you a good credit risk?" you know how to answer.

It's satisfying when the world sees you the way you see yourself, and a lot of that is up to you. But when these two points of view don't coincide, it is important that you at least see yourself clearly. You get to be the one to decide who you are, what you are. This self-definition will help you continue to make art no matter what else is happening in your life. Your family might not understand you, your employer and coworkers might not understand you, and I know that Internal Revenue won't understand you ("Well Mr. Smith, what you have here is a hobby!"), but you'll know who and what you are. You'll know what your priorities are, too. But it takes time, courage, and *stubbornness* for most of us to reach this point.

Why "stubbornness"? Isn't that a bad trait? It can be, but it can also work for you: The word implies a certain mulishness, true, but also a quiet, firm—even unyielding—resistance to pressure. This

might be a necessary stance for you to cultivate. It will certainly help you continue to make art throughout your lifetime.

Many creative people I've spoken with realized at a very young age that their passion was art, and they often discovered early that they were already at odds with the people around them. One of the most moving stories I heard was told to me by Jerry Barrish, who grew up with "no painting, music—nothing that dealt with the arts." He describes a school field trip that he took when he was about seven years old: "We went to the de Young Museum. That was the first time I had ever been exposed to any art at all. It was a religious experience for me—I was flabbergasted by it. I was so upset at all the other kids making fun of the cherubs and all that stuff. I just couldn't deal with how silly everyone behaved in this—this temple."

If we say "I'm going to be an artist" as we're growing up and sound like we mean it, reactions will differ, but there will be a reaction. Sheba Sharrow says, "My mother didn't want me to be an artist, because her vision of an artist was somebody like in *La Bohème,* who had tuberculosis and starved in a garret." And there wasn't much encouragement for her to stick to her decision as she grew up, she recalls: "It was very hard, because in my generation there were all kinds of pressures from society to get married, have children, and 'settle down.' That was the big number."

It was only a little different for me. I am a woman and was born just after World War II ended, and I realize now that I met with much less opposition than, say, my brother would have, had he decided that he was an artist. For women of my generation and background, the reaction may have been infuriating—many contemporaries recall hearing the response, "Good, you'll always have a hobby"—but at least I wasn't actively discouraged. This difference in response, depending on an artist's gender, was illustrated to me again years later when my neighbors, both artists, were temporarily without money jobs. "She's an artist, he's unemployed" was the neighborhood attitude.

One woman close to my age remembers that her parents' response to her proposed plans "wasn't 'You're going to be an artist and you're not going to make any money.' It was 'Why do you need to do anything, anyway? You're a woman.' "

Apart from dismissive attitudes such as that, it's natural for

parents to worry about their children's well-being. If a daughter announces she is joining a high-wire act or a son decides to hunt great white sharks off Dangerous Reef, few of us would say "As long as you're happy, dear." We might end up saying it, but other words would come out first.

But when the child has grown and his or her career is underway, many parents still worry. "Even after I had a show in a museum, which I thought would sort of wave the magic wand, really calm them down, I had a revealing talk with my father. What was really on his mind was, 'This is all well and good, but what is it really doing for you?' I think he's talking about financial security."

Good guess. Financial security and art do not often coexist, in spite of the firmly held misconceptions of a few. (I spoke once with a man in his late eighties who informed me, "Artists make a lot of money. A *lot* of money.") Most people know better than this, so you'll likely meet with incomprehension and perhaps even hostility when you say "I'm an artist" to your family or the rest of the world.

So don't say it. Feel it, and then act. Don't waste your energy trying to convince others; they probably won't believe it even when they do see it. Practice your most mulish expression, and shut the studio door.

It seems to me that people either think of you as you were when they first met you, define you in terms of what their own interests are, or see you simply as they want to see you. Jerry Barrish says, "The people that I've known the longest just do not accept me as an artist. The people I met in the course of filmmaking have a hard time thinking of me as a sculptor."

In my own life, my nonartist neighbors understood it when I was teaching in college and making art: They said, "She's a teacher" and seemed proud of that. Now that I've stopped teaching and started writing, one regularly asks, "You still on vacation?"—after four years! Occasionally I try to "bear witness" for art by showing my studio and work to interested people. I feel it's important to demonstrate that art is a normal human activity, but I don't give tours all that often, I'll admit. I'm optimistic or egotistical enough to think it's a worthwhile effort to make, but acting on that belief is a drain.

Another artist puts it a different way when asked if she tells casual questioners what she does: "It depends how much of a conversation

I want to have with that person. If I feel they really want to know something about me, I'll say 'I'm an artist.' But then they'll say, 'What do you do?' and I have to get into a really complicated description. So sometimes I make something else up."

I don't remember making anything up when asked that question, but once, while traveling alone, I told a limited truth. I had ended up in a small guest house in Scotland, and I decided to identify myself to fellow guests only as a teacher. This was for a specific reason: I knew I'd have an easier time of it there—and more fun—as a teacher than as an artist. There were other teachers on the island, and people understand "teacher," while they often seem confused or shy around "artist." I knew who I was and why I was there, though. I was there to draw!

Even within the art world, you need to be the one to define yourself, and as precisely as possible. Again, it may take some stubbornness to do this. Jerry Barrish, for instance, defines himself as a sculptor. He says, though, "Theoretically I've had much more success with my films than I've had with my sculpture." More people probably see him as a filmmaker, but so what? They don't get a vote.

Sometimes this external pressure starts in art school: You "should" major in painting, even though your heart belongs to sculpture; you "shouldn't" concentrate on drawing, because it's such a struggle for you. Occasionally students are pressured right out the door. I remember a fellow student who left two turbulent years into a four-year graduate program. Twenty-five years later, unlike many of the people who "successfully" completed the program, she's still making art. (I knew she would be, too.) So who's the success? A degree doesn't make you an artist, but stubbornness might. It will certainly help.

Something else that can start happening even while you're in art school is pigeonholing. You might find yourself being identified in a specific way and subtly pressured into making art that conforms to that identification. For instance, in the late sixties, exhibition opportunities finally started to open up for African American artists, but I worried that their work was "supposed" to be identifiably African American to be deemed authentic or relevant. What if an artist really felt a perverse pull toward still life? Would the work still be shown? How free would he or she be then?

A little later I experienced the allure of this pigeonholing first-hand when women's art was finally starting to be shown more. My work fit then into the "relevant" themes of the era, and I decided to take advantage of these exhibition opportunities. But I was always wary of the subtle pressures that even the most supportive art structures can exert. I still am. This paranoid attitude has helped me in my dealings with galleries, too.

Another way that art schools can inadvertently damage students is when teachers imply there is only one way to be an artist; they offer one definition. It's probably different for every generation of artists, but an example of that pressure when I was in school was the repeated admonition: "Only by having a studio away from home can you be 'taken seriously' as an artist." That didn't work out for many of us, especially after children or other responsibilities came along.

One artist remembers a less articulated message that had long-lasting repercussions: "When you're in school, it's 'You're going to be a full-time artist, and how dare you be anything else? How dare you have a real life in addition?' It took me years to say that it was OK."

Another artist's statement is more measured, but it's just as deeply felt. She says, "My art is very important to me, but I don't want to just think of that as the only way I can allow myself to be creative." She finds herself slowly breaking away from many of the dogmatic "givens" presented to her in school.

Take some time to think about the definition of "artist" that you grew up accepting or that you absorbed in art school. Is that truly your own definition? Is it the way you see yourself or the way you're living your life? If it's not, consider this: Maybe it's the definitions you're still living with that are wrong, and not you.

To see yourself differently than most of the world sees you can be a lonely feeling, but with art only so much alignment of self-definition and external definition may be possible. Since your priorities and goals are so different from most other people's, it's unrealistic to expect them to understand or care too much about your life in art.

People do like labels, though, so they'll try to define you, maybe as child, wife, husband, mother, father, friend, teacher, or office manager. In the art world you'll be defined again, perhaps as African

American, feminist, gay, realist, painter, or filmmaker. I wouldn't waste much energy arguing with other people over labels, should you disagree with them; it needn't concern you. The way you define yourself isn't ever up for debate.

What matters is your work. What matters is telling the truth about yourself through your art. Your stubbornness will help you keep that in mind.

And if you're stubborn enough to decide you're an artist, you're stubborn enough for anything.

## *Self-Reward:* *Working without External Rewards*

There's not necessarily a correlation between how hard an artist works and how well he or she will be rewarded for that work. It's a little like the comic strip character sitting in the pumpkin patch; his sincerity doesn't mean anything is going to happen.

It's not that nothing is ever going to happen for the artist. Something great might happen, but for some people that hope can be worse than the idea of an anonymous life in art. The attention, money, and status that a few artists receive begin to seem like attainable goals.

And then come our rewards: A piece is finally accepted into a juried show halfway across the country, which will end up costing you a lot and will boil down to just one line on your résumé; an offer of representation is made by a gallery, which may then hold you responsible for all framing costs and will give you 50 percent of the selling price—if they sell anything, and if you can collect; perhaps, if you're really doing well, an invitation comes to show in a college gallery, which probably will involve you paying all framing and shipping costs, with little chance of selling anything. A lot of good artists aren't even this successful at showing their work.

On the other hand, lines on your résumé eventually add up, my experiences with galleries have almost always been positive, and the benefits of showing in a college gallery—particularly the student contact—make the costs seem worthwhile. I think, though, that the artist who can separate his or her work from expectations of reward has a better chance of remaining a lifelong artist.

Expectations seem to change with each generation. One artist complains that he "bought into the belief that artists should be

noble and suffer, and that is their truth." A more contemporary point of view is that artists' work should be rewarded, just like any work—and rewarded well. This seemed to hold water in the eighties, and I'm sure that a similar feeling of entitlement benefits some artists today. Certainly many of us could use a little of this confidence.

But few will experience the external rewards that this attitude presupposes. Does that make us fools for continuing to make art? Would it make more sense for us to go out and buy those lottery tickets instead?

I believe in making the effort, in presenting work to the world, insofar as the world is willing to receive it. I believe art deserves respect, and that we should be respected for making it, whether it's possible to sell it or not.

A 1989 article by Alfie Kohn in the *Los Angeles Times,* however, explored the connection between reward and creativity and came to some interesting conclusions. The author said, "Psychologists have been finding that rewards commonly interfere with performance, especially where the performance involves creativity." He went on to say that rewards seemed to make creative activity less enjoyable to the creator, less intrinsically interesting. He reported that studies were finding that rewards tended to encourage people to focus narrowly, and to do so quickly. These people became less willing to take risks while working.[6]

This brings into question how desirable consistent reward would be to an artist, although it isn't something about which many of us really have to worry. I think most mature artists could handle reward just fine, if they got the chance. But I think it is wise for every artist to spend some time thinking about external rewards. How important are they to you?

One artist is clear on this point: "For me, the reward comes from acceptance of my work through academic situations," such as shows in college galleries. He has taken the time to figure this out and doesn't even think about financial reward.

Which seems most appealing to you, attention, money, or status? None of them? All three? There's no point in saying something— money, for instance—doesn't matter to you if it does.

That brings up another question, though. How much reward would be enough for you? A painter corresponds with a prominent

foreign composer. She writes to him: "It always surprises me, and I see it all the time—no matter how celebrated an artist is, it's never enough. Never enough. We always want more." She adds to me, "I'm sure that's true of every single artist. I think it's universal that we all want to be recognized, but to have that child in us be too loud is to allow ourselves to be too vulnerable to outside influences." I think that the recognition that no reward would ever be enough anyway might help some of us settle more peacefully for what we get.

If there's some external reward you'd truly like, evaluate how likely you are to get it through your art. If you're already getting the reward you want from art—status in the community, perhaps— recognize that, and appreciate it. If you aren't getting the external rewards you need through your art, you'll either have to get them some other way, go through life aggrieved, or reevaluate your needs. Scale them down, perhaps.

And you can compensate. I'm a believer in self-reward, in giving yourself, as far as you are able, what the world can't or won't. You might reward yourself merely for being an artist, for making art. Give yourself the gift of time: "I'm going to take the entire weekend at the end of the month just for art. Phone off the hook, no shaving, the works." Give yourself nourishment: "I'll bring home take-out after work for the next three nights and go straight into the studio after we eat."

One of the things that can be hard to explain to others is a small victory in art. So reward yourself when you finish a difficult piece; buy a special art book or magazine. If you get into a juried show or receive even a glimmer of encouragement from a gallery or consultant, take a friend out to breakfast or award yourself $25 to spend on an art material you've never used. Reward a successful show (it's successful if it's up) with a pair of earrings, a massage, or a new tie. Reward completing a year's serious work with travel, if at all possible; choose a destination for its current exhibitions, museums, or just because it's beautiful.

Some of these rewards are little carrots at the end of the stick and some are very big carrots. But the point is, make the effort to thank yourself in some tangible way for your art, even if all you can afford is espresso with a friend or an expedition to the park. Just because you're the one giving the reward doesn't mean it's not worth

having. Sporadic treats, however small, help keep interest up, and that has to be good for the art.

But perhaps the best present you can give yourself as an artist is an appreciation of the internal rewards you are already getting from your art. Most of these rewards have to do with the process of making art and not with the finished work. There are physical rewards. One artist says that making art gives her "an energized feeling. It's like I could do anything." Exhilaration!

A young dancer once told me that he didn't take drugs because of his dance. When I asked, "Do you mean because drugs would hurt your dance?" he said, "No! I mean I already get that feeling—*from* dance." I knew immediately what he meant. Perhaps this physical sensation is common throughout the arts. When it happens, everything about you and your work comes together for one timeless moment. It doesn't happen that often. You can't call it forth or count on it, but when it does happen, it feels great.

Art satisfies our senses in other ways as well. Many artists describe their materials so lovingly and in such detail that it's like eavesdropping to listen to them. They talk about the smell of damp clay, the feel of heavy watercolor paper . . .

And then there's the emotional satisfaction of self-expression and the spiritual reward of being a creator. To quote a lifelong artist who knows what he's talking about, "It is a temptation to say that I feel sorry for anyone who isn't an artist!"

## *Open-Mindedness:* Evaluating Your Own Work and Progress

"I never thought I had the skill—I still don't believe I have the skill to paint. It's like a big wall in my head." The man who says this is, of course, a painter, and even though he's up against the "wall" daily, he continues to paint. He's a good painter, too.

It reminds me a little of a television show about perception I once saw: A baby creeps along on a clear plastic floor that covers a large boxy structure. Where the box stops, the baby stops, even though the sturdy plastic floor extends far past the box's edge. But the apparent edge is as far as the baby can permit himself or herself to go.

Artists keep on going. Their hearts may lurch as they crawl beyond the box's edge, but they do it.

Most artists experience something like the painter's "wall"; they are familiar with the lurching sensation. "What am I doing?" "Did I really make that?" "Can I still do it?"—and this can be with an art process with which the artist is extremely familiar!

To be open-minded is to be receptive to new arguments or ideas. To this definition we can add being receptive to new feelings, such as the uncertainty about work, the fear, previously described. Perhaps "open-hearted" would be a better term. Anyway, it's a quality we can all cultivate. Open-mindedness is essential for artists because it enables us to critique our own work.

For those unfamiliar with the word "critique," "self-critique" sounds about as appealing as taking out your own wisdom teeth, but it's not that bad. Critiques start in art school and usually involve a teacher and the entire class commenting on individual work. Critiques can be devastating or productive, occasionally devastating *and* productive. A lot depends on the teacher. But no matter how scary the process is, the student knows that there's not much point in having a teacher say, "Everything you do is wonderful. I like you just the way you are!" again and again.

Once you're on your own, you are the teacher. You are in charge of your own critiques for the most part. Visitors to your studio might make critical comments or your work may be reviewed, but the most important critique will come from you. You're the only one who really knows what's going on with your work.

That won't keep other people from giving you advice. Just try to stop them! "Go to more openings and network," "Build a career—it's just like any other business," and so on. It's probably obvious by now that my own bias is more the "Stay in your studio and work" or "Let your work speak for itself" variety. But everyone will have something to say: It's all true, and none of it's true—true for you, that is. Your own open-mindedness will enable you to cannibalize what you need from all this conflicting advice and use what you need. This will involve ignoring a lot of advice, though.

It's strange, but if you're a person who worries a lot about being universally liked or approved of, you're forgetting something obvious: It's an impossible goal. Do you think there's not someone who feels that Michelangelo should have married and raised a family? That Frida Kahlo was being a little bit obsessive about her accident? That Picasso was a total rat because he used women like paint rags?

You can play that game with anyone: O'Keeffe? Probably a dud at parties. Giacometti? Not very well-rounded—and so on. Give it up. Someone's going to take exception to your life, to your art. To quote from a song that Thomas "Fats" Waller made famous in 1922, "There ain't nothin' I can do nor nothin' I can say, that folks don't criticize me. But I'm going to do just as I want to anyway, and don't care if they all despise me . . ." Why not just go ahead?

So first you have to do it, make the art, regardless of what people think. And no matter how gregarious or career-oriented you are, it's important that you be free—and unobserved—when you do this. You need to be free to feel the lurch, the terror, and you need to be free to make ridiculous mistakes. Put off even the self-critic until later.

Doug McClellan says you want to get "into the middle of the process, then you can thrash around, discover some things, and really get some work done." But he also observes that we have to train the "critic who sits on our shoulder not to screw things up, but to let the rules be made up as things go along."

It helps if you're making art that truly means something to you (see chapter 6, "How Do You Discover What You Want to Say?"), in a way that's relevant to you (see chapter 7, "How Do You Discover How to Say It?"). One artist exults, "I'm really making art that I love. I have to make no compromises with it." It took him a long time to find this art, and he struggles with it, but he has a certainty that sustains him.

It's also helpful if you develop some understanding of the reasons you love your art. Virginia Cartwright says, "I want it to be like nature made it, like a flower unfolding. And if it doesn't look that way . . . watch out!" Sheba Sharrow's response to a writer who wished he could change her subject matter was, "You can only do that if you change the world." These are two different statements, but each is authentic to the artist. And again, it took these women years of open-minded evaluation of their own work to reach these levels of understanding.

There are different kinds of self-critique that can be productive to an artist. In a way, the artist critiques each piece as he or she is working on it, although it is important not to let difficulties with any one piece become overwhelming. This is another of the reasons I find it valuable to work on several pieces simultaneously. Still, you

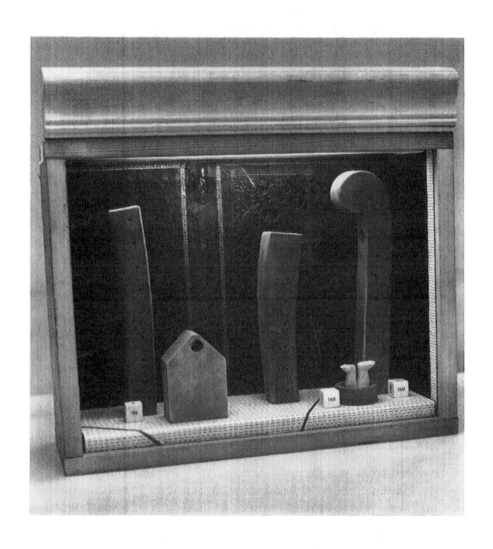

*A Cautionary Tale,* **Doug McClellan,** assemblage, 16″ × 17″ × 6″.
Photo by Wilfredo Q. Castaño.

can ask yourself "Is this piece serving some purpose to me or my work as a whole? Am I moving forward?" about each piece on which you work.

The last thing you should be thinking of is what the critical or commercial response to the piece will be.

When you have been working in depth for a while, you will soon have a body of work. Now you can ask yourself a wider variety of questions. You could look at the physical work itself and ask, "Am I using the right materials for what I am trying to do? Is my skill with the materials improving?" You might evaluate the size in which you are working and ask, "Is this size logical in some way? Does it still look and feel right to me?" and so on.

You could also critique your work open-mindedly while considering its emotional impact. You might ask, "Does it move me in some way?" "Do I still care about it?" or even "Do I love my work?"

The spiritual questions can be even more challenging. You could look at a body of work and ask, "Am I still telling the truth?" "Is the struggle still going on?" I think it should be.

It's fairly easy to ask even these questions. It's a little harder to answer them honestly. But really listening to the answers is what will call for your open-mindedness.

It's obvious that these are questions that only you can ask, or answer. That's why I consider self-critique the most important kind of critique there can be for an artist. And it's never over.

But occasionally we feel the need for an outside opinion, and this too calls for an open mind. One artist says, "When you're starting out and you don't know what direction you're going in, you don't even know if what you're doing is good or not." He feels that he benefited from external advice during one such period in his creative life.

Another artist was humble enough to learn from unasked-for advice. He remembers, "I had a show, and another artist came up to me and said, 'These look like you're an illustrator or something.' I said, 'Oh, geez.' So from then on I tried to loosen up a little bit and not be so precise. That was a turning point."

If you seek out a critical response from someone, it is important to choose that person carefully. Here is Jerry Barrish's description of the sort of person he looks for: "I think you have to be encouraged by a person whom you respect, someone who really likes what

you're doing. It's not a matter of public evaluation, of consensus or anything, but sometimes you have doubts, and you have to be able to go to somebody and ask their opinion."

Your attitude toward external critique may change back and forth over time. Harrison Storms now makes a much greater effort than he used to in soliciting response to his work. Speaking of his earlier attitude he says, "I didn't want to be influenced by any other artists. I didn't want to have them come in and say, 'Hey, that looks great just the way it is,' whereas I might feel 'God, no it doesn't.' "

He is describing one of the possible drawbacks to external critique, undue influence. This artist was afraid that other artists might change his own perception of his work. Additional outside influence can come from galleries, if you exhibit. This can be so subtle, that "what happens is that people are losing their freedom, and they don't even know they're losing their freedom," as one sculptor observes.

I hope I'm open-minded enough to believe that external critique can be valuable and productive under certain circumstances. We all want answers, advice. But apart from soliciting critical response carefully, my advice is to avoid external critique of work in progress. Put that work away and focus the critique on a limited number of completed works. Do this occasionally, if you find it helpful.

Remember, though, that the solitary experience of that same rigorous procedure of self-critique is when you'll "really get some work done."

## *Perspective:* *Valuing Your Art and Creativity More than Society Does*

The *Los Angeles Times* has a daily section called "Calendar" that covers "entertainment, the arts, and TV listings." Prominently featured each day is the gossipy "Morning Report," with headings such as "Pop/Rock" and "Movies," which consists of paragraph-long stories from national and international news sources.

When an "Art" item pops up in this report, it is virtually always about money: A painting sells for a huge amount at auction, or fails to sell; a valuable sculpture is discovered to be a fraud and therefore loses its value; a celebrity collects or sells pieces for vast sums. That's entertainment.

It's not just the *Los Angeles Times* that links art to money, of course. Stories of (almost) priceless paintings discovered in attics or at garage sales are perennial folklore. The unspoken punchline of these tales is always, "Who knows what's lying around? That old painting might actually be worth something!" Who would have the glory, by the way, the person who made the painting or the person who "discovered" it, and sold it?

Movies about now-famous artists always include a scene that juxtaposes the apparent worthlessness of the artist's work in its own time with its extraordinary monetary value today. We see the artist slink away when the work is refused as payment for a café tab, or we watch the recently deceased artist's relatives heave paintings into the basement. Then we have the contemporary auction scene . . . The unspoken punchline of this old story is, "They were such dopes then! How could they have been so blind? Had they but known," and so on. And who says this, the collector, or the person who walks past studios and galleries every day, never pausing to investigate?

But it's no wonder that so many people think of money if and when they think of art. This leads to contemporary art work being bought (and sold) for its "investment value." "Who knows what it might be worth someday?" And it leads to increased pressure for artists who, after all, have grown up surrounded by this same commercial emphasis. One artist described her early difficulties justifying the extra expenses her art incurred: "Well, it is hard, and unless you feel that you're going to get some return for it, it's doubly hard." Money down the drain . . .

As art students, we anticipate a period of financial struggle but feel that the struggle will eventually be rewarded. Even my generation, teetering between the old art-as-calling concept and the newer one of art-as-career, embraced this vague notion. The idea of art "paying off" flourished and even grew in the eighties: What about trying for more success, and sooner? Why not? Don't artists deserve it?

For most artists, though, commercial success never happens, no matter how much they deserve it, certainly not sustained commercial success. Even artists whose work eventually sells for fairly high sums usually aren't able to support themselves and their families through such sales. The artists certainly can't count on sales for regular income. So when I ask one painter (whose work is exhibited

and often sells) if his family recognizes him as an artist, he says, "Yeah. But they wish I was successful at it."

When the people around you realize that you may never have the kind of "success" they grew up envisioning, mental adjustments have to be made. You may have to make them, too. It's very possible that your life in art—your *successful* life in art—might be a struggle from start to finish. It might never "pay off." When an artist ironically tells me, "You're supposed to have something to show for your labor," he is talking about money, because that's the reward we've been taught to expect. But artists need to develop a different perspective on reward, on success.

Just as the combination of art and money equals entertainment for many people, so do artists themselves, or the idea of them. Artists are sometimes thought of romantically as quixotics, seers, or mystics, but more often today they are popularly viewed as willful eccentrics, misfits, even tricksters. People love to be shocked by artists' perceived antics—the work they "pass off as art," or their "sexual exhibitionism." Opportunistic politicians cash in on this delighted outrage, so conveniently diverting, and the hostile climate heats up. Maybe there's an art equivalent to the "greenhouse effect" that happens. Anyway, every so often artists become the guys people love to hate.

Some artists thrive on this hostility, but others find it just another burden, something else to get past on the way to the studio. Again, these artists have to hold a different perspective; they need to see themselves as creators and not art entertainers. There's nothing creative about pandering to society.

When you are an artist it is important that you not let society place the definitive value on your art or your creative life. Don't wait for that approval or validation. It will probably never come, and if it does, you'd better be suspicious of it. Don't wait for society's permission to start being an artist, and don't let external reactions stop you. Art is too important for that.

In the church in which I was raised, a sacrament, we were told, is "the outward and visible sign of an inward and spiritual grace." I think of this when I think about art and creativity: I see art as the "outward and visible sign" of creativity, which is the "inward and spiritual grace."

There's another, less religious perspective on the word. Other

*Leaves on Rock,* **Sally Warner,** charcoal on paper, 14" × 14". Photo by Claire Henze.

definitions of sacrament are "token" and "symbol," "oath" and "solemn pledge." I think that creativity might be seen as a personal sacrament, a solemn pledge each of us can make to himself or herself. And art is the symbol of that promise.

However you look at it, value your art. Specifically, use the best materials, time, and space you can afford. Don't devalue your art by giving it away, unless you know the recipient will truly love it. Don't talk about your work to people who don't care about it. Take at least the same care of your finished work that you would of other valued possessions. And if you aren't selling your work, don't try to attach monetary value to it. The work exists with integrity, independent of monetary value. A thing doesn't have to be saleable to be valuable. Think of it this way: Imagine that you have a glorious dream one night. The dream "really" happens; it might even change your life. But how much is it worth? $50? $5,000? Imagine that you fall in love. What is the value of that experience? $1,000? $100,000?

And value your creativity. Guard it, and cherish it. Don't try to justify your creative priorities to people who will never understand them. You already know that when you are creative you are at your best. Creativity is one of your highest functions. Don't try to fit creativity into your life or work around it; put it where it belongs, at the center of your life. Say, as one artist says, "This is the truth for me, so this is what I'm doing."

Some creative lives could be represented by unbroken lines. There would be ups and downs, yes, but the lines would be unbroken. Maybe that's the way your life is going. But even if the line has been broken once, twice, or a dozen times, you can make room for art again and reexperience that inner grace I spoke of earlier. It might just be a matter of changing your perspective: You be the one to value your art and creativity. Give yourself that.

Whether your creative life has been a broken line or an unbroken line, if you're lucky, one day you'll be able to say what vibrant, lifelong artist Sheba Sharrow says: "I've begun to feel lately that just being able to do what I want to do is the greatest gift I have in this life."

Trust an artist.

# How Do You Discover What You Want to Say?

## A Guide to Subject Matter

WHILE CONTEMPORARY ART certainly doesn't need to be didactic, carry a specific message, or even be easily categorized, the artist working free of external structure (such as that provided by a school) must be independently able to sustain an interest in his or her subject matter and in the art material used. This chapter explores the value of discovering a personally meaningful subject upon which to focus for an extended period of time.

It is most uncomfortable for an artist to lose sight of his or her most authentic voice. One artist says, "I'm aware that at certain times in my life I painted what I thought was expected of me. It was, 'What is the going style? What is current on the market?' What people expect you to do." Another artist observes, "I suppose when you're relatively young and relatively unsure, you want to make all the moves right so that you're 'making art.' " It is extremely hard to be an enduring artist with creative motives like these. The rewards of this second-guessing and tightrope walking simply won't be great enough to sustain the work. To keep on making art, an artist needs to be both excited by the process and convinced that he or she has something to say.

But what *is* subject matter? The term sounds antiquated and limiting: "I paint seascapes (down by the seashore)," "I work from the nude," (a wonderfully ambiguous statement), and so on. A young artist says, "When I was in school, there was such a taboo against the 'precious art object' and being part of the commodity structure, the art machine. I feel like that was a little misleading in a way. I think now of trying to make things that could be in a gallery. It's embarrassing to admit it—for my generation it is."

An artist's work doesn't have to be "precious," and his or her subject matter doesn't have to fit an easily defined category. Subject matter could be the exploration of a color, an idea, or a space. Stephanie Rowden describes a large installation she created: "This room in the museum had been a room that ordinarily holds painted portraits. I really wanted this piece to speak to the act of making a portrait in some way. So there's some logic there." Nowhere in this installation was there a traditional portrait, but the piece was made up of vivid portraits nonetheless.

LaMonte Westmoreland's work often addresses social concerns by mixing message with humor, but it's always serious. He recalls the late sixties and says, "There were things going on at the time. I had to get it down, get it down in work for my own sanity, because these things were gnawing at me. There's a lot of injustice that's going on." He's still hard at work. Three thousand miles away, another artist has a similar feeling: "You can't isolate yourself from world events. At least I can't."

Sometimes artists' preoccupations show up in a different way in the work. Harrison Storms says, "Nature is always evolving, it's always changing, and it's pressing against civilization. The whole idea behind my work is that everything is in constant change, and we find that aggravating. My materials allow me to express that." He adds, "Before, I always thought of transition as moving into darkness, but now I see it as moving into light." His newest work reflects that altered viewpoint.

## Describing Subject Matter

How do artists describe their subject matter? I have discovered many artists to be articulate about this, once they get used to talking about it. Artists work in isolation, and it is clear that they spend a lot of time thinking, on different levels, about what it is they're doing.

An important part of this contemplation for many is a broad examination of subject matter: What is the point of view? My own most fundamental shift in viewpoint was a shift from looking within (literally, as much of my imagery came from microscopic photography) to looking out at the world. This mental shift was represented in my work by a dramatic change in subject matter. I started to draw

*Relics #19,* **Claire Henze,** manipulated gelatin silver print, 14″ × 11″.
Photo by Claire Henze.

the real things that surrounded me. The way I saw the world and my view of my place in it changed simultaneously. Like many artists, I didn't plan the details of this shift in advance. I only became aware of them as time passed. Sometimes an artist discovers his or her subject matter while working, or even in retrospect!

No artist gives up on introspection, of course, but I discovered an irony: I was better able to express my most compelling emotions by looking out at the world. Another artist voices a similar feeling when she says, "I think now, as I'm older, it's become more important to me to deal on a deeper, more inner level, not just about myself, but about the world around me."

Things change, but in some ways they stay the same. Doug McClellan says, "I think you only have about six ideas in your life, and you keep coming back to them. Certain configurations keep coming up. I think they develop rather early."

It is very common for a theme to repeat itself in an artist's work. Claire Henze says, "One of the recurring preoccupations in my work is transition, the evidence of process and change created by light, by time, and by the impact of life. Photography inherently has a strong sense of time passing, and thus is a powerful tool to comment on that theme." She remarks that two of her early series "deal with stages of life that pass quite quickly," while "in the recent *Relics* series, the sense of time is slower."

Stephanie Rowden says that she always tries to capture "moments where different sensations of light and sound and smell come together all of a sudden in a very surprising and full way. But more than that, I think the work has a lot to do with memory and imagination and personal histories."

Diverse cultural influences are acknowledged by LaMonte Westmoreland, who says, "In some of the works I will take an image maybe from Rembrandt, a face, and then I will split it, and then maybe part of the face might be an African mask. So I'm connecting to both cultures. I feel a connection to both."

The broadest possible viewpoint of subject matter is expressed by Harrison Storms who tells me, "I like to imagine that I'm somehow looking at things from a great distance, where I have the freedom that I can look at time, look at a million years as though it happened in a minute." He goes on to say that he senses this struggle, "but it's

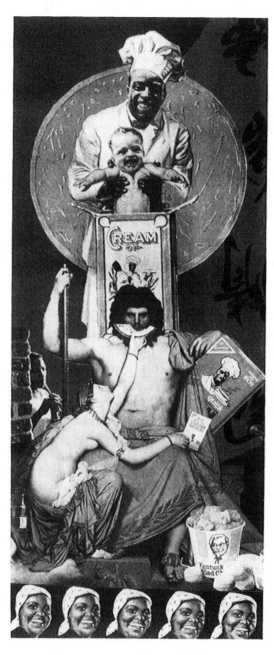

*Jean-Auguste-Dominique Ingres, Jupiter and Thetis Eating Melon,*
**LaMonte Westmoreland,** mixed media/collage, 24 $^1/_2$" × 9". Photo
by LaMonte Westmoreland.

not a struggle of anger. It's a much more poetic kind of struggle, where everything's trying to fit together. Some things are going to be lost, and some things are going to win out."

All of these are sweeping statements, yet each expression is clearly visible in that artist's work. Each artist is describing, in a general way, his or her subject matter. Their work has to stand on its own, as most artists would prefer theirs to, but sometimes I think it's too bad that the person viewing that art can't know its history!

Artists are also able to describe their work very specifically, although they do so in different ways. For example Doug McClellan, who currently concentrates on assemblage work, notes, "I found recently, especially in the cages and in the boxes, that two objects together can resonate in such a way that they really set all kinds of things in motion."

LaMonte Westmoreland, who often includes African American "pop art icons" in his work, speaks of this specific theme when he says, "I think about black images being used to promote a particular product for dinero [money]." Another artist is talking more about the overall look of his finished pieces when he says, "I like things that look like they've been dug up after centuries."

It is obvious by now that my definition of subject matter is not simply what, if anything, is being depicted. No one I have spoken with describes his or her work solely as "still life" or "landscape," for instance. Even when these terms can be used as accurate labels, they aren't of much interest or concern to the artist. These traditional labels make it easier for people to categorize you and your work, but the terms rarely approach the truth about you or your art.

I think it is more productive for each artist to look at subject matter from a personal perspective. Some of the things that interest and preoccupy the artists I spoke with are the relationship between objects, struggle, transition, social issues, memory, personal history, and—repeatedly—time. Yet few of these things are considered traditional subject matter.

Many artists say that their work is autobiographical, although that is not always obvious to the viewer. If your work is at all autobiographical, then, in a way, you are your subject matter. Some artists say there is no obvious personal history in their art: "If there's

*The Sea,* **Sheba Sharrow,** acrylic on canvas, 64" × 78". Photo by Steve Cicero.

anything autobiographical about it, it's more subconscious—like reading ink blots or something," says one.

But other artists can trace their entire lives through their work. Sheba Sharrow says, "I think I've come full circle. When I grew up in Chicago, there was a certain ethos. It had largely to do with a kind of social consciousness. I started out painting like that—it was just before the fifties. Then during the seventies I found myself fairly isolated, alone with two children to bring up, and just beginning my own feminist consciousness. We tended to look inward. Then my sense sort of went out into the world again, and all the things that I saw and felt that were happening in the world began to creep into my work."

Claire Henze reflects on the influence catastrophic illness has had on the way she sees the world, and on the art she makes, when she says, "I think now about the passage of time and about damage to the structure of things. Evidence of process interests me. Change shouldn't pass unnoticed." Speaking of the natural objects she has recently chosen to photograph she says, "These things I have found along the way, forms that have held life, have taught me about the beauty of the underlying structure and about what is left behind."

Sometimes, something bad happens at one point in an artist's life, and later, that artist realizes that his or her art has been changed for the better by that event. For instance, a few years ago, when artist Stephanie Rowden spent a month immobilized following surgery and another six months recuperating, she remembers, "Going back to that time of being in a cast and spending a fair amount of time lying down, I think that's when I realized that I really loved the radio, and that I really loved to listen to stories. I have a lot of respect for people who can tell stories well." Much of her subsequent work combines storytelling, sound, and sculpture as she creates haunting installations. So in this indirect way, her art can be said to be autobiographical.

Occasionally, the personal link between an artist's work and his or her life is apparent only to the artist. Harrison Storms describes a series of large paintings he has been working on and says it is "based on the Sibyls and Prophets in the Sistine ceiling—they're trying to break loose. It's their nature to change. Oh yes, it's autobiographical!" he adds.

*Beyond the Wall #15,* **Harrison Storms,** acrylic on masonite, 64" × 47".
Photo by Harrison Storms.

## *Discovering Subject Matter*

Another artist refers to an artist's few most passionate aesthetic concerns as the "gyroscopic principle you operate by," and I think that expression well describes the sensation of inevitably returning to certain subjects. But how do artists first discover their subject matter? Sometimes, the subject matter seems to find the artist. Claire Henze says, "Usually the subject finds me initially, or I stumble upon it or discover it. It sort of calls you. It says, 'OK, come on!' You know, you see it, it rolls around in your head. I don't sit in my studio and think, 'What am I going to photograph next?' "

My own impulse several years ago to draw landscape felt less like a decision than it did like being hit over the head by the obvious. I had been visiting friends in Canada during a spring break in my teaching; on the last day of my visit, while preparing to return home, I suddenly thought, 'I have to draw this.' Almost overnight I was turned into what I now think of as the Art Vampire, a person scheming for time, money, and access to places I want to work. And I'm a better person for it—well, a better artist, anyway!

Jerry Barrish describes the genesis of his current sculpture: "What happened was, when I was picking up materials, I started seeing images in the materials. Then I started to link things together. And then, it just started to go."

Sheba Sharrow tells the story of one series of work: "It all started when I was in the Philadelphia Museum of Art. I saw a Greek metal helmet that had been excavated from old ruins, and fused to the helmet was a piece of skull. I saw that as a perfect metaphor for man's fusion to war. From that, and from my two trips to Greece and Italy, evolved the *Warrior* series."

One of the best reasons for an artist to keep on working regularly in the studio, even if the work feels unimportant, is that he or she often makes important discoveries while working. Or while playing. As Doug McClellan says, "When you play, you don't make the distinction between this and that. *You just do what you do as generously and with as much attention as you can, and then that's it.*" This is a good recipe for just about anything, but it works especially well for art.

A painter notes that playful, experimental work in the studio often leads to more serious work: "A few times, I've had a single image in

my mind, and that materialized and then led to the next one, to the next one, to the next one. One thing sort of feeds off another. You get into working, and this mental or psychological space begins to expand. But you know where you are. It's familiar territory, so you keep going."

Travel always provides people with new things to see, and often familiar things are seen with fresh eyes both while traveling and upon returning home. Sheba Sharrow, remembering the beautiful old walls she saw during her trips to Greece and Italy, says that they "reveal a kind of time, a record of time exposed. How many centuries they have stood, and how little human nature has changed in all that time! A sense of the irony of it all began to influence my work very much."

Old walls influence the paintings of another artist, too, but more directly. Harrison Storms says that his work "has a lot to do with responding to commonplace things, and one of the things I like are old walls, like the backs of old garages. You know, they're hot, and bleached, and they're just wonderful." He recalls, "When I went to Italy, I saw even older walls, and I just fell in love with them. The history, the layers, and the way they absorb the colors. People paint over them, and piss on them, and draw on them, and they just keep building up."

At home in Los Angeles now, he senses a connection between the changing nature of these surfaces and his current surroundings: "I mean, it's like living in L.A. The building is there for five years, and then it's gone. Something else is there." We talk about earthquakes and the violence that is part of life in Los Angeles. He says, "Twenty or thirty murders a week occur in Los Angeles sometimes. We live in a particularly violent time. Bang! Things just change so much." He adds, "We as a species—if we're going to survive, we've got to change, somehow." Change is evident both in his painting process and in his finished work. His paintings seem full of memory, grounded and ethereal at the same time. Images appear to shift and move even as you look at them.

## Changing Subject Matter

Artists can plan work up to a point but need always to remain open to change. If an artist clings too long to an idea that no longer

interests him or her, then that artist becomes simply an illustrator of some emotional or intellectual past, rather than an artist. One of every artist's most challenging jobs is to stay constantly attuned to what is true for him or her in the present; the alternative is to participate in a process that becomes more and more automatic. The work may still look like art for a while, but it feels hollow. The artist becomes too unsatisfied to continue this work for long.

This isn't to say that the artist shouldn't plan future work or keep working through dull periods. Sometimes such a period goes on for a long time, in fact, and the artist simply has to trust that it will end. Give it a while. But it is important to point out that as long as the artist is alive, he or she is never finished changing; the artist is never "there." The process of internal change is never over, so the work will always change, too.

One artist says, "Before I went down to the Virginia Center for the Creative Arts, I had a whole series of things floating in my head that I was going to do, and when I got there, I did something completely different. I'm not that methodical that I can sit down and make an outline and fill it in like you were doing a thesis or something like that. But I think, generally, you know the kind of thing that you want to do."

When I first made the decision to concentrate on drawing, I started on a series of large charcoal drawings of women's heads. I soon ran into the practical problem of not being able to coordinate the models with my available work time. I was teaching and had young children, and it was a difficult thing to do. After a period of frustration and struggle, I decided to draw plants instead; they would always be there in the studio, waiting, whenever I found time to work. But for me, the important thing about this switch was the realization that the drawings could still be the ones I started out to make: I could try to draw the plants with the same love I felt when drawing the people. So I suppose you could say that my underlying subject matter was the connection I felt with whatever real thing I was able to draw. This became a change in outlook as well as a change of subject matter.

Claire Henze's work also changed when her children were young. She says, "That's when I started taking the Diana [a simple camera] to things like kids' birthday parties, which normally I couldn't stand. But suddenly I could make it part of my work."

An artist's work usually changes a lot during his or her creative lifetime—naturally, since the work reflects the artist's own growth and change. For some artists, these changes are subtle, gradual. One man twenty-five years into his life as an artist reflects, "I think the work has been pretty consistent over all the years." If you were to view a retrospective exhibition of his work you would see changes, but the "gyroscopic principle" mentioned earlier would be obvious.

Other artists' work changes dramatically, but usually that individual principle is still evident, or it would be, if you could get enough distance to see it. Artists may make big changes in subject matter, in materials; they may suddenly find (or lose) their most authentic art. But usually the sympathetic viewer would be able to follow the thread, to trace the journey.

Sometimes an artist is alert to internal changes that are taking place, changes that affect subject matter. Says one, "Opening myself up to include other people in my work process—that's fairly recent. I think that was a really big step. And that was a hard step, because usually, as artists, we don't open up by showing those vulnerable early stages so much. We work things out privately in the studio."

Many artists become aware of important changes they have made only by looking at their finished work, though. As one artist puts it, Alice-in-Wonderland style, "It takes me quite long to really digest what a project has become once it has become the thing that it is, which is always different from what you thought you were starting out with." Ditto.

When you are a student, your subject matter is usually assigned to you. When you are first on your own, perhaps you experiment with different materials and ideas, or perhaps you cling to familiar means of expression. In the midst of so much sudden, apparent freedom, it is easy to neglect to give sufficient energy or attention to what it is you want to say with your art: This is a time when it is easy to slip into someone else's subject matter, and it's easier to do that than it is to slip away from it later.

Imagine this: During your creative lifetime, a hundred people will attempt to tell you what your subject matter should be. Only occasionally will that message be obvious; usually, you won't be aware of the pressure that it is being exerted.

Imagine that ten of those voices come from your distant past. They are saying, "This is what art is." You can't even remember

hearing them. Another ten voices come from the time you spent in art school. These voices say, "This is the art that is worth doing; this is what it looks like. This is the way to be an artist."

Imagine that another ten voices accumulate after you leave school. These voices belong to friends whose work you admire. Then there is the work you see in galleries and museums: At least ten voices seem to say, "This is the important work." And if you are represented by a gallery, you may hear, "Do you have any other pieces like this one?"

Imagine that ten voices emerge during your lifetime from social or political causes that concern you. They say, "Don't waste your art, use it for change." Or voices may nudge you onto the "correct" path in subtle ways. One artist says, "There's a lot of artists that do things because it would be acceptable in the community, you know." I know.

When work is reviewed and you read those reviews, ten more voices accumulate. They are impressive, reasonable, and some seem to speak directly to you: "This is the serious work of our time." If your work is reviewed, imagine yourself in the peculiar position of being told what your subject matter really is by someone who seems to know better than you! Jerry Barrish says, "A lot of people add a dimension to my work" when they call it environmental art. When I ask whether he sees his work this way, he states flatly, "No. I don't." He won't be pushed into that category, either, but it could be a battle for some.

Awards and grants are given, and you examine the lists of winners for signs and portents. Imagine that some of the invisible juries behind these lists eventually make up another ten influential voices.

You read interviews with celebrated artists, and you read books by or about those artists. Imagine that you are markedly impressed by at least ten of these word-sanctified artists; you suddenly feel that these artists are doing the work you should be doing.

Critics and assorted others writing about contemporary art sound much surer about everything than you feel about anything, and you listen to ten of them. They might say, as one recently has, "The great collective project has, in fact, presented itself. It is that of saving the earth—at this point, nothing else really matters . . ."[7] Nothing else matters! These voices are articulate, confident, and sound smart. They say, "This is what you should be doing."

Imagine that ten of these voices are so convincing that you find yourself considering a change in direction to illustrate their theories.

The last ten influential voices are unpredictable and catch you by surprise. They sneak up on you: They could be the sneering throwaway comment you overhear, the random sentence you read, the social pressure you feel, perhaps through direct or indirect censorship, the large piece you sell. Imagine these last ten voices.

No one lives in a vacuum, of course, so some degree of external influence is operating whenever you make a decision. And you may find yourself in total alignment with a voice or two; that's fine. The purpose of this cautionary tale is merely to illuminate the difficulties facing you as you attempt to discover what it is you want to say. Don't let your subject matter be handed to you, overtly or covertly, because if you do, there's no way you'll be able to sustain your interest in that work for long. If you become a "hired hand" serving someone else's ideas, you'll soon discover that the pay stinks. One artist who has survived some of this pressure says, "I think you have to be committed to yourself first, and then whatever happens, happens."

## *If You Need Some Help*

If you need some help structuring your exploration of subject matter, I suggest that you thoughtfully select one subject, and make the commitment to focus on it for an extended period of time—at least six months. Make your selection a specific one. Use your intuition in making your selection if an immediate subject doesn't come to mind. Specificity will enable you to explore something in some depth; the subject will become more interesting to you. For example, rather than say, "I love birds, so I guess I'll paint birds for a while," narrow it down. You might decide, "I want to do a series of very large, square paintings, using acrylics. Very intense colors. I want them to be extreme close-ups of wild birds in cages—lots of detail." Or you could say to yourself, "I'll use torn painted papers in collage to create eventually a whole flock of imaginary birds. I'll work on foam board, 18 by 36 inches each, and then hang all the collages together like patchwork."

Your choice will be strongly influenced by the art material with which you choose to work. Or it may be the other way around for

you: You may start by choosing a material with which to work and then select your subject matter.

If you have trouble deciding what it is you want to work on for six months and decide to proceed intuitively, there are several approaches you can take. For instance, you could take a look at your external world. Do words excite you? One artist refers to "the tussling with words as symbol" that is a recurring artistic theme of his. There are many ways that you could use words in your art—through collage, using rubber stamps, with photocopy art, or in painting. Stephen Freedman, a Los Angeles–area artist, creates huge clay vessel "poems" by cutting letters from thin sheets of clay.

Another artist's passion is people; she says, "I somehow suffer for the underdog always, and identify with whoever is being exploited or martyred." This artist's subject matter is grounded in her compassionate response, and it is authentic to her. But artists are not propagandists, and your life in art is not a competition to find the worthiest cause to illustrate. Good causes don't automatically mean good art will follow. Part of your necessary selfishness has to be the search for the work, whatever the subject, that will engage you. Your goal is to keep on working, day after day.

Immediate external surroundings may point you toward your subject matter. What music do you listen to? What books do you love? Are family photographs among your most treasured possessions? You might plan a series of watercolors, each pairing people from different generations. Or you could build a honeycombed wood box and stain its niches with rich, dark colors before adhering selected photographs to create a sculptural decoupage construction.

What physical objects do you collect? Which of them has emotional significance to you? If you love old tools, you could use them as inspiration for a series of etchings. If you hoard and treasure antique fabrics, you might enlarge some patterns from your old flour sack collection and use them to develop a series of serigraphs. Or you could imprint heavy old lace on porcelain clay (using plastic wrap as a barrier) to use in sculpture, or you could use large sheets of thin Japanese paper and create detailed overlapped rubbings from the lace.

You could use the old question "What would you save if your house caught fire?" to discover the significant objects in your immediate external world. What things would you save?

What about your internal world; what furnishes your mind? Again, look at the music and books with which you surround yourself. And what keeps you awake at night? Do you plan the future, dwell on the past, or imagine a different present? Do you plan how to spend your lottery winnings, wish you had longer legs, imagine great love affairs, nurture feuds? Don't be ashamed by the triviality of your preoccupations. Turn them into art. I'd be interested in seeing someone's extended exploration of any of these topics, wouldn't you?

Hold up an invisible mirror and look at yourself: Do you see what the rest of the world sees? You might work on a series of contrasting self-portraits, if the images are different. If there is no difference, you could attempt to draw, paint, or sculpt a series of identical self-portraits. This would be interesting, because they wouldn't end up the same at all. The differences among them could be revealing to you.

Investigate other cultures. Read about them, and go to museums. Do you feel that something is missing in your life? You could fashion your own artistic version of the Mexican milagros, those tiny charms that depict the body part that needs healing. Invent a symbol to represent what you are missing.

What about your dreams? Some cultures pay a lot of attention to dreams. You might depict vivid scenes from your dreams over a period of time; you'll remember the dreams more easily as your work progresses. Does an occasional person in your dreams seem more real than many of the people you meet? Attempt a portrait of that person, and find out why he or she is so important to you. Or perhaps you could change the outcome of a dream as you work. Give yourself a happy ending!

Remember the old story of the drowning man whose life flashes before his eyes? If you were drowning, what vignettes do you think you would remember? Don't wait until it's too late to turn them into art. Some of my strongest memories are visual ones of commonplace things. Are yours? Look at the colors in your memories, the flash of a tiny red tee shirt at dusk, the yellow plastic shovel and pail half buried in wet sand, the white dress that hangs against a painted white door. You could make a visual "scrapbook" of your strongest memories.

Your subject matter certainly doesn't have to be figurative. But if

your interest is as broad as the relationship between two random objects, for instance, remember to be specific in your focus: Your goal is to sustain your own interest for at least six months.

Or your subject matter might spring from an art material you decide to explore in depth. Again, narrow your focus enough to present yourself with a challenge that is engrossing in its depth rather than frustrating in its breadth. For example, you might decide to work with soft pastels for this specific period of time. Commit yourself to one project. You could explore various pattern or color relationships on black paper or use the pastels with water to "paint" a series of cityscapes from your bedroom window.

## *Working in Series*

It is obvious that focusing on one subject or medium for an extended period of time means that you will create a series of related pieces; it is likely, even desirable, that you work on more than one piece at a time in that series. I have found that working on several related pieces simultaneously (never more than five, in my case, though often fewer, depending on what else is happening in my life just then) enforces a distance that is beneficial to the work.

Doug McClellan points out a different benefit of working in series: "When I first discovered the value of it, I realized that we have different kinds of energy when we're working in the studio. Sometimes it's starting-paintings energy, and sometimes, every eighty-eighth day, it's finish-paintings energy, but in the middle it's just get-in-there-and-push-things-around energy. And a lot of time, if you only have one piece going, you come equipped with the wrong kind of energy." He adds that when you work on several pieces at once "you saturate yourself with one problem, and then you present yourself with another problem, and it appears easy. I work in batches of anywhere from five to twenty-five related works. The individual works begin to speak to each other and in time begin to explain things to me. With a number of paths you can really explore."

Another artist makes a practical observation when he says, "I try to work on maybe five or six pieces at a time. If I'm waiting for something to dry here, I'm over there, dealing with that."

One series of work leads naturally to the next. In this way, an artist's subject matter changes over the course of his or her lifetime yet remains true to that artist. But how does an artist know when a series is finished? If you are trying to establish or reestablish a structure in your studio life and have made a specific project commitment, you will benefit from honoring that commitment. It's more important now that you keep working on the series than it is that the series remains fresh. This discipline will pay off.

A similar series of disciplines benefits the work of any enduring artist, but intuition about the status of the work plays a bigger part as work progresses. In determining the end of a series, for instance, one artist says, "I usually go about two steps beyond it." Then his intuition kicks in, and he changes course. In addition, the experienced artist is flexible and constantly fine-tunes the initial vision as he or she works.

## *Dealing with Barren Times*

There are two basic approaches to dealing with those inevitable times when nothing in your work speaks to you. These are the times when this misery, coupled with art's usual lack of tangible rewards, makes a life in art seem foolish. The artist can sicken of art.

One approach is to pull back and stop working during these times. Some artists feel they must allow time for their voice to reemerge, and they find other things to do while waiting for this to happen. This period can be a time of growth, often enhanced by time spent thinking, reading, or looking at other artists' work, but the danger is that the art may simply slip away entirely. If you follow this passive approach, you may be giving your art too great an opportunity to escape.

One definition of inspiration is breath, and for most artists, inspiration needs the air of the studio in which to flourish. If inspiration comes to you while you're hang gliding, chances are it will evaporate by the time you float back to work. So the second approach is the one I most recommend to artists who have any trouble at all dealing with barren studio time: Keep working anyway. Simply pick a subject or material at random, if necessary, and work. This work will lead you toward the work that you will love.

If you feel so poisonous that you're sure you'll ruin whatever you touch in the studio, do studio chores instead. Sort supplies, photograph work, label slides, or write letters. But do these chores *in the studio*. That way, you'll be in the right place when the breath, the inspiration, returns.

It can be hard discovering, or rediscovering, what it is you want to say. Once it happens, though, you'll be able to breathe again.

# How Do You Discover How to Say It?

## A Guide to Materials

> **"I have tried to present my sensations in what is the most congenial and impressive form possible for me."**
>
> **—Edward Hopper**

**M**OST OF US REMEMBER Rat in Kenneth Grahame's *The Wind in the Willows;* he's the one who liked "messing about in boats." Well, artists like messing around with art materials.

If you majored in art or went to art school, you probably had a variety of classes in two-dimensional and three-dimensional art and were introduced to many seductive materials. At times I viewed this varied curriculum as an updated if diluted version of the ancient apprentice system, wherein the student/apprentice would slowly accumulate necessary skills. Occasionally, gloomily, I saw our training simply as a sort of future job insurance: Who knew what he or she might be asked to teach one day? Most often, though, I thought of our various classes as a sort of smorgasbord. We were to taste it all, then decide what we liked best. That would be our art, or at least our final project.

Now, twenty-five years later, I think that all three notions were right, but with a twist. For instance, when I recall my "apprenticeship" with some teachers, I remember their idiosyncrasies rather than their specific assignments. I learned the most from the idiosyncrasies. There was the drawing teacher who lovingly delineated the model's form, which, try as I might, I always saw first as a flawed body. There was the otherwise rational teacher who wasn't embarrassed to blurt out that he hated purple and didn't want to see it in his class.

There was the design teacher who seemed to invent his increasingly intriguing projects solely for his own enjoyment. I learned things inventing a twenty-five letter grid alphabet (with two clicks) for space aliens, and I had fun, too, but that teacher was having an even better time.

**137**

And there was the sculptor who taught stone carving in silence, his face transformed by a grin only when my "precious" sculpture split apart shortly before the end of the semester. "A hidden fault in the alabaster," he said. There sure was, but the fault really lay more in my attitude toward my work at that point. The apprentice system worked!

And job insurance: even I, who never intended to teach, eventually used every scrap I learned in those classes when I did become a teacher. I even used every scrap I thought I'd forgotten.

As for the "smorgasbord," I discovered that you can't really separate the things you learn. When I draw now, for example, I often feel close to my remembered sculpture experience. And of course you often combine materials and are unlikely to go through your creative life without changing from one form of visual expression to another; some of the artists in this book demonstrate that.

Virginia Cartwright suggests an additional reason for a broad arts curriculum when she says, "I knew exactly what I wanted to do in school, but they wouldn't let me do it. In the sixties there were people waiting out in the hallway to take ceramics, so to take care of this they made you take four semesters of life drawing, two-dimensional design, three-dimensional design, wood shop, and metal shop first." And it was her experience in metalworking that ended up being an important influence on the structure of her later work in ceramics.

But there's one negative aspect to having so many satisfying firsthand experiences with all those materials: We aren't able to spend enough time really thinking about any single material. Do you use an art material now because it's the perfect means of expression for your art, or might your choice be inspired more by familiarity and facility? Could you be continuing to use a material out of stubbornness, snobbery, or inertia? One artist ironically remembers using "oil paint, *of course*," for years, before deciding that he'd really like to try something else, something less "serious."

Don't let your materials bully you. And whatever material you end up choosing, make it a conscious choice. Taking the necessary time to make that choice a thoughtful one, even if you feel you are mulling over the obvious, is important. Taking time out to think is an advanced—and usually productive—thing to do.

The art materials and methods that each artist uses should not just be passive tools but should themselves express something of the

artist and his or her feelings about the world. If you take this approach, you'll not only have more fun, you'll make better art. You will still struggle with whatever material you select, but at least it will be an informed, loving struggle. You'll know that you have made a deliberate choice—the right choice for the present, at least.

Making such a choice is an example of providing yourself with the structure you need for a life in art. Face it. By the time you finish school, you are probably so well-rounded that you could easily spend the next ten years bouncing all over the place. Printmaking? Of course. Painting? Sure! Welding? Throwing a pot? Making paper? No problem. You can do it all.

But can that actually *become* a problem? Not always. Sometimes artists are so engrossed in the later, more specialized projects they've done in school that they are able to continue making their art after graduation with few problems. The previous work provides a structure on which the artist can build. But often the artist's very well-roundedness is the problem: He or she either can't decide what to focus on or else resents being told to focus at all. It's too much fun just "messing around." However, as Doug McClellan notes, "Play demands an open attitude, but it can be trivial if there is nothing at stake—and, at some point, limits."

If you bristle when you hear the words "focus" or "limits," then of course you'll continue the work you're doing now. That's fine; certainly no one will tell you to change. The awful thing, or the liberating thing, depending on how you look at it, is that no one else really cares about the art you make—you may be the only one. You care. And maybe you know that a playful period, a period of exploration, is what your art needs right now. Just keep track of the time; time has a way of going by faster as you get older.

But you could spend your whole creative life in the exploration phase, jumping from this project to that. Lots of artists do. Unfortunately, the "something's missing" feeling that eventually ensues often means that your creative life will be a short one. Maybe that's already happened to you.

## *If You Need Some Help*

When you feel you're ready to focus, perhaps after such a period in your life, or when you're ready to refocus on current work, or ready

to change focus for a while, your effort will be rewarded. The same approach I suggested in chapter 6 works here, too. If you need some help getting started, I suggest that you thoughtfully select one art material, and make a commitment to work with it for an extended period of time—at least six months. Use your intuition in making the selection if logical thinking doesn't work.

This chapter looks at a variety of art materials and methods in what will probably be a different way from the one you're accustomed to. The description of each material has much more to do with an artist's personality than with the material's technical possibilities. Perhaps this chapter will help you reevaluate familiar materials for the right philosophical match and help you decide on which material to focus. At the very least, I hope you will be inspired to view the materials you work with in a different light. Even if you end up using exactly the same materials you always have, at least you'll have a better idea why!

But take pleasure in taking time. Slow down and think about the tools you choose, the materials you use to express yourself. Ask yourself questions, and consider your many options. Find the poetry in those materials. It's there.

One way to go about reconsidering the materials available to you is to start big: Look first at the broadest choices you have to make, taking your subject matter into account, of course. For instance, do you want to work two-dimensionally or three-dimensionally? What size?

What follows is an overview of my own experience in discovering how to go about making these decisions. Maybe it will help you. When I first went through this process a little more than ten years ago, I felt I was inventing it out of desperation as I went along, and it was hard. I had been out of art school for ten years, and, though I'd kept making art the entire time, I had become increasingly unhappy with that art. Now I understand that many working artists must have gone through similar experiences, but it didn't seem like it at the time. In fact, I spent the first painful part of that time looking at the biggest question of all—whether or not to continue making art. Looking back on it, I can't remember how serious I was about quitting. Maybe it was never really an option, but it seemed serious then. I decided to continue.

Once I got that decision out of the way, I spent a long time thinking about what I wanted to "say" with my art that was so important to me

that it could survive probable indifference and obscurity. Only then did I start to think about the broad physical choices I had to make and the materials I could use. I still wasn't making any art.

For me, thinking about the physical form my work would take was primarily an intuitive process, but not entirely. When I asked myself "two-dimensional or three-dimensional?" for example, I chose two-dimensional partly because I'd recently experienced a hurried move into a smaller space, and a lot of my art had been damaged or destroyed. I was now working (or not working) in a barely converted one-car garage, and I realized at last how important it was to me to be able to protect my work. So that influenced my choice to work two-dimensionally. It influenced the size I chose to work in, too. Another reason I chose to work in two dimensions was to satisfy the need to make a record of my reactions to the things around me. I didn't want to make big physical objects; I'd had enough trouble with objects during that move. I didn't want more *things* to take care of.

I spent a lot of time thinking about size. I had been making large paintings, or they seemed large to me. But as I sat on the floor thinking about them, I realized that they had rarely exceeded five feet, four inches in height, my own height. It hadn't occurred to me before, but obviously the size of my work was "personal." It was based on human scale—mine!

(It was about this time that I overheard a motley group of neighborhood children lowering my youngest son into a pit they'd dug in the wild part of my backyard: "It's two Andrews deep," one child reported.)

Once I realized how basic, if childlike, my response to size was, I was able to overcome my previous indoctrination against "small" art. I stared at the wall, imagining different sizes, still not having decided on materials. My extended arms roughly matched a standard paper size, twenty-two by thirty inches, and that was the size in which I decided to work for a period of time. Storage drawers were readily available for that size paper, so my strong need to better guard my work was satisfied too.

Next, I decided specifically on drawing. Why not printmaking, collage, or painting? I had found printmaking too indirect in the past. And I certainly didn't want my images reversed at that time in my life; things were mixed-up enough. Anyway, I didn't have the necessary equipment.

Collage appealed to me, and it still does. But I realized that I felt like a walking collage myself at that point, all patched together. I didn't need the novelty or surprise of collage. I needed to slow down and think.

Painting? That's primarily what I'd been doing for the previous ten years—that, and drawing. I could have chosen painting rather than drawing, but I no longer felt able to safely store canvases. And there was something about paper . . . the cold-press watercolor paper I settled on had such a warm, inviting surface. Any slicker and the paper would have seemed to turn a shoulder to my images. Any rougher and it would have taken them over, muscled them aside.

What about painting on paper? I didn't like the idea of painting in oil on paper. I needed my images to be more permanent than that. And I didn't like the way acrylics looked on paper. They were too shiny, too reflective; I didn't want to be pushed away by the image.

Watercolor was a possibility, but I was overly calculating when I painted in watercolor. I couldn't grapple with problems as I worked, and I needed to do that.

Drawing gave me that opportunity, I realized. I needed drawing, a direct, intimate means of expression. I decided against using color; color would have been a distraction for me then, so that eliminated colored pencils and pastels. (I had always used pastels more like paint, anyway.)

In considering whether to use charcoal or ink, I found myself leaning toward charcoal. I remembered the artist and teacher Charles White and his use of the material. I loved ink, but, considering my needs at that time, there were a number of points against it. There was my aversion to the reflective surface, previously mentioned; I wanted to sink into the work, not be kept away from it. And you can't change ink. You can't move it around once it has dried, and you can't work into it as you can with charcoal. I needed more flexibility than ink provided. I needed to be able to reconsider, to find my way as I worked.

Finally, I needed gray. Not gloomy gray, but all the beautiful gradations: I was interested in the hundreds of values there are between black and white.

So charcoal was the answer for me. Its simplicity appealed to me, as did its history. Surely charcoal was the first drawing material ever used! Well, maybe a finger in the sand was first, but charcoal wasn't

*Lågnäs/2,* **Sally Warner,** charcoal on paper, 14″ × 14″. Photo by
Claire Henze.

far behind. I could imagine my charcoal floating on the paper's surface as if it had been born there.

This intuitive process took me close to six months of studio hours. I was also teaching part-time at a community college and raising two young children. I often felt as if I were wasting time in the studio, but I wasn't. Still, many of those hours were spent mentally flailing around. The process doesn't have to take that long, incidentally, but be patient enough to give it the time it needs.

I include this personal history in the chapter as an example of how the process unfolded for me. It will be different for you; obviously your own needs and aesthetic biases differ from mine. But I think you can see how and why I reached my decisions. I intended to use this structure as a framework for at least eighteen months' work; it's been ten years, and I'm still drawing.

There are two things not to give too much weight to when starting this process. The first is the question "What am I good at already?" This might be what you finally settle on, but occasionally acclaim or facility sets an artist on a course that's hard to leave. Put those praising voices out of your head, and listen to your own voice. And as for facility, it may be telling you you're making the art you should be making, but for many artists facility can be more of an enemy. Don't be afraid to struggle for a while.

The second thing not to take into account is the worldly purpose of your art. Do not worry about what you're going to do with all that work or about who will buy it. Don't make art, or at the very least this art, serve a purpose beyond itself. For instance, resist making big art if you feel like working on some smaller pieces; big art might feel more "important," more corporate, but that's not a very good reason for working big. Make big art for the right reasons, the personal reasons, and not just to snag a commission or impress a curator. This art must feel authentic to you.

In deciding whether to work two-dimensionally or three-dimensionally, think first about which form of expression you really need right now. It's true that most two-dimensional work is easier to ship or store, but that shouldn't be a factor in this choice.

In its most fundamental sense, I think that two-dimensional art, no matter how sophisticated, is "I made my mark!" art. It tells the world that you, an aware being, were here. That can be a satisfying feeling, and sometimes it's exactly what a person needs.

*Blue Boy,* **Jerry Ross Barrish,** assemblage/found objects, 13″ × 8″ × 7 ¹/₄″. Photo by Dan Oshima.

Sculpture or other three-dimensional art is a different record of your existence. I think this art comes from the builder, the maker in us. It says, "I'm here. There's no getting around me." The three-dimensional artist creates physical objects that take up space in the world. He or she uses variations of practical, homey skills—constructing, shaping, assembling—to make art, something that transcends both the skills and the materials. Sometimes this very physicality is what an artist needs. It can give you the feeling that you belong on this earth, that you are part of things.

Size is, as I discovered, a personal thing. As you already have at least a rough idea of your subject matter in mind and have decided upon either two-dimensional or three-dimensional expression, now is the time to envision size.

I think we look at art in relation to human scale, at least when we see it firsthand. We see a tiny work: "I could hold it in my hand!" Michelangelo's *David* is—big. So is Seurat's *Sunday Afternoon on the Island of La Grande Jatte*. These works look big because we know human beings made them and because the size of the pieces makes us feel small.

It's interesting, by the way, when we first see a work we're familiar with only from photographs, and we are surprised by its size. We get the accurate feeling that we've previously missed something important about the work. The artist made the work that small or that big for a reason.

When you envision your work's size, you don't have to think consciously about human scale; you'll do that automatically. But try to "see" your intended work. How big is it? What about its shape or proportions? Is the work essentially round, square, earthbound, soaring, squat, elongated? Do the size, shape, and proportions suit what you want to say?

Now it's time to look at specific materials.

## Two-Dimensional Art

### Drawing and Painting Surfaces

You can draw or paint on many surfaces, and they don't have to be flat, of course. But to simplify things, here's a look at three common surfaces you might consider.

First there's paper, the most historical and traditional surface for

drawing. No matter how avant garde your work, drawing on paper connects you with the past. There are many beautiful papers of varied thicknesses, textures, and colors from which to choose, and if you want to work big, some good papers come rolled. Since you are likely to pin the paper to the wall or a board, the paper's surface will be unyielding as you work. You are able to concentrate wholly on the image. Many papers are well suited for painting, too.

Illustration board is another good drawing surface, and it also works well with some paints. You are more limited as to size, texture, and color than with paper, but this surface basically provides its own drawing board. It is subsequently easy to use outdoors and while traveling; it lets you work spontaneously.

Canvas is the traditional surface for painting, but it can be used as a surface for some drawing materials, too. If left unprimed, canvas is absorbent, and the edges can be torn or frayed. If it is unstretched, you probably will work against a wall or board, as with paper, and the resulting surface will be unyielding.

But there's something about painting or drawing on stretched canvas, whether primed or unprimed, that you may find immensely satisfying. I think it has to do with the "give" you feel as you press against its surface; the surface feels almost as though it's breathing. Canvas could be the surface for you.

## Drawing

### Charcoal and Pencil

Drawing, as I have said, is an immediate and direct means of expression. Some people still think of drawings primarily as "sketches," as work done in preparation for a painting, but drawing is much more than that.

When you draw with a dry material such as charcoal or pencil, consider that dryness and take advantage of it. You can move the material around, alter it, work into it with your fingers, a chamois, an eraser, or a tool such as a stomp or tortillion. If you like to solve problems and keep options open throughout the entire working process, you could choose to work with these materials.

But a word of warning: Even with charcoal or pencil, which enable you to keep work in flux for an extended period of time, you can go too far. If you overwork the piece, the life will go out of it and you'll

never get it back. Working on more than one piece at a time helps you avoid this, as does taking time to step back from work in progress.

Some pencils have a cool, reflective sheen, and that might suit your needs. Others are dense and seem to reflect no light, there's just the mark on the paper. You have to supply the light.

## Ink

Wet ink looks so lush, so black. It invites both the sweeping brush stroke and the tiny scratched line. It demands spontaneity, and that may be what you're looking for.

There are two black inks I like to use: India ink and bottled sumi ink. India ink is easier to find, but if you are making wide strokes, its slightly shiny dried surface is apparent. You might like this look; it provides some textural variety and catches the eye. If you prefer a matte ink finish, try the bottled sumi ink. Both inks can be thinned with water to create grays, but only India ink is waterproof when it dries. Is it ever: One of my earliest art disasters occurred when I spilled India ink on a beautiful old oriental rug . . .

There are many varied drawing tools artists can use with ink. You are sure to find one that suits your needs. For instance, if you want a loose fluid line, or if you just want to loosen up a little, try using a sumi brush. These brushes come in many thicknesses. Each brush holds a lot of ink, so you won't have to keep stopping to reload.

Think big when you draw with a brush, even if you work small.

"Pen and ink" has a long tradition, but a pen can be a very contemporary drawing tool. Remember, though, that you're not writing the Declaration of Independence. Use the pen to draw with. Don't clench it and sweat. Take advantage of the uneven lines that you make, and rejoice in unexpected blobs and spatters of ink. Using a pen doesn't mean that you have to work tight, and the combination of the history, unpredictability, and beauty of the material could be ideal for you.

If you want to try something different, draw with ink, using ordinary sticks as your drawing tool. This forces you to give up some control, which may be a goal of yours. I once saw a film of Matisse drawing in his later years that inspired me to try something similar (in what I hope are my middle years): I tied a little chamois square to the end of a yard-long bamboo garden stick and drew with that. Try it—a wonderful line can emerge, seemingly from some place at

the back of your mind. Hold the end of the stick, though; if you find yourself gripping it three inches from the chamois, you're missing the point. Try to force some distance, and "kill the hand," as the Zen saying goes.

If the idea of loss of control, blobs, or spatters gives you a hollow feeling, read on. There are always technical pens. These have come a long way since I first used them; back in those days, they were perversely satisfying—unless you were on a deadline. You could spend so much time soaking them, shaking them, and squinting uselessly into their clogged points that you hardly ever had to actually draw! But I hear they've improved.

The chief characteristic of technical pens is a steady, unvarying line. Its thickness doesn't change. If you want a thicker or thinner line, you use a different pen. This line quality doesn't have to look "technical" or dull, though, and it may suit your needs. If you draw with these pens on rice paper, for instance, the paper will ensure some line variety. The line also can be interesting when combined with a more irregular ink line on any drawing surface.

One newer drawing tool that I've used a lot is the Pigma ink pen. This pen is not refillable. It comes in various point thicknesses and is permanent, lightfast, and waterproof. A double-ended sumi brush pen (nonrefillable also) contains the same ink. These pens are ideal to travel with, and the brush pen will keep you loose. The brush pen makes a nice scumbly gray mark as the ink dries up, too.

There are other nonrefillable pens with which you can draw. Just check that the ink is waterproof and lightfast. The same warning holds true for colored inks: Do a little homework before you buy. Assume the most for your art—that you'll want to keep it forever— and buy accordingly.

## Colored Pencils

Here's your chance to use some color! If you feel like drawing, want the control of working slowly, and like to build your image gradually, try these. The pencils available now are very different from the wimpy ones we bought to tart up school maps. You can buy colored pencil sets or individual colors.

Colored pencils are among the most popular "new" materials. There are many methods you can use to create rich, vibrant drawings far removed from the ladylike shadings of the past. Bet

Borgeson has written some good books outlining various colored pencil techniques; look for them.

If you enjoy reflection, planning, and working in layers, you will like working with colored pencils. They also force you to slow down, and that might be a good thing.

## Pastels

There are two kinds of pastels you can draw with, soft pastels or oil pastels. Either material can also be used to create paintings, so pastels can really be seen as a bridge between drawing and painting. In fact, since you hold the pastel sticks in your hand as you work rather than using a brush, pastel painting is almost like finger-painting in that it's a direct way to work. You're close to the drawing surface, and you feel each mark you make.

I like to work with pastels on white watercolor paper, but both soft pastels and oil pastels are opaque and can be used effectively on colored paper. Canson Mi Teintes paper is ideal, and it comes in many colors.

You can buy soft pastels in sets, but you can buy the best ones individually, too. They come in hundreds of seductive colors. You can use a chamois, stomp, or tortillion as a drawing tool if you'd like. They can be combined with other media; LaMonte Westmoreland sometimes uses soft pastels in his assemblage work.

Soft pastels have an expansive, dreamy quality. This can be a welcome counterpoint to a jangled life. They force you to ignore the tiny details that may have distracted you or impeded your work in the past; soft pastels force a generosity from you. Draw with the pastels alone, or use them with water to make a pastel painting. You can either dip the soft pastel into water before a stroke or apply the pastel to a wet surface.

When soft pastel drawings are finished, they smear, although pastels worked with water smear a little less. You can spray the drawings or paintings with fixative. Use fixative with adequate ventilation, outside if possible, use a mask if you have one, wash your hands after you use any spray, and never use sprays around food or drinks.

Be alert: If you hold the spray can too close to the work, the spray dries a little shiny and may change the colors somewhat. Spray many light coats instead. Your goal is for the surface of the work to appear unchanged.

Oil pastels are vivid, brilliant, and exciting to use. The colors are brighter than those of soft pastels. In fact, using oil pastels is a little like using oil paint. You can even use oil pastels with turpentine, although given my bias toward permanence in materials I would gesso a paper or canvas drawing surface before doing this. Like soft pastels, oil pastels are sold in sets, but the best brands also sell individual replacement colors.

It's hard to be timid when using oil pastels. They encourage the bold use of color, the sweeping vision: No one has ever drawn angels dancing on the head of a pin using pastels! This might be your chance to stop being finicky for a while. Whether you're making a line drawing or layering and mixing colors like paint as you work, oil pastels are an exciting material to use.

## *Painting*

### Watercolors

I think every artist has had the thrilling childhood experience of painting with watercolors—and has also experienced disappointment when his or her picture turned to mud. I remember hearing a painting teacher I once had say, "It takes two people to make a painting, someone to paint it and someone to shoot him before he ruins it." This holds especially true for watercolors, which can be characterized as "unforgiving." (In art, this adjective means that you can't go back into the work and change things or cover them up.)

In a way, the funny thing about watercolor paintings is that they appear so spontaneous, when in fact you have to do a lot of planning to make them look that free. Once you cover that white paper with paint, it's covered. It's as though you have to do a lot of the painting in your head before ever mixing a color; in that sense, working with watercolors has something in common with ink drawing or stone carving.

So you either have to work truly spontaneously, painting areas of color that you can bear to accept and leave alone, work cautiously, using the watercolors as a secondary medium—to add a little color to a drawing, for example, or really understand what you are doing. When you buy the colors, you don't automatically know their lightfastness, staining propensities, how "cool" or "warm" they are, or even how transparent they are. All of these things affect your work.

But they're all learnable. There are many how-to watercolor books available if you didn't learn about watercolors in school. Look for books that spell things out, ones that give specific colors and brand names. Avoid the tricky ones, the Chinese-horses-prancing-in-the-mist books.

Of course you don't have to review all that material if you are using the paints to create the spontaneous areas of color mentioned earlier or if you just feel like experimenting. That can be fun; buy a set of blank watercolor paper postcards and enjoy yourself!

If you haven't shopped for watercolors in a while, you're in for a treat. The tubes of paint come in dozens of colors, and there are even metallic watercolors available now. And there are solid water-colors, the familiar kind sold in plastic pans, that are far removed from the ones you muddied as a child. Pelikan sells an especially nice set of solid artist-quality watercolors, and the individual colors are really big enough to use. This is a good, easy set of colors with which to travel.

If you want to feel spontaneous or experimental, if you are able to accept things the way they turn out, and if you like the idea of transparency—of transparent areas of color shimmering against beautiful white paper—try watercolors. Again!

## Gouache

Gouache is a little more forgiving than are watercolors. Gouache is water-based, as are watercolors, but it is an opaque paint. You can cover up things. Gouache is often used by graphic artists and illustrators, but it is also a fine-arts material. It is sold in tubes. (By the way, if you are as reluctant as I am to ask for something you can't pronounce, it's "gwash.")

Why would you choose to paint with gouache? Perhaps *because* it is more forgiving. If you feel like exploring a water paint but like the idea of secrets, of opacity, you might want to paint with gouache. The colors dry matte, and this flat evenness could serve your needs too.

Gouache is like a very good poster paint, and like that paint, once it has dried it will be reliquified by further layers of water or paint. This can be a positive or negative quality; either look at it as a positive quality or try another material.

## Acrylics

Acrylics first became commonly used in the sixties, which was when I was in college, so I had half my training in oils and half in acrylics. Acrylic paints were viewed with a lot of suspicion then and in fact were not the same high quality paints we know today. At first they were viewed as poor substitutes for oil paints, and artists sneered at how "plastic" they looked when they dried.

But the paints caught on and quickly grew in popularity as they improved. Now they are widely accepted.

The amazing quality acrylics have is that they are water based, yet they dry waterproof—and quickly. This was seen as a drawback by some oil paint devotees, since it meant that you had to work fast and couldn't change what you'd painted once the paint was dry. You could cover things up, though; acrylics enable you to solve problems while you work, as do oils. You just have to solve them a little faster. Today, acrylics' quick-drying property is seen more as a difference than a drawback, although acrylic retarder (to slow drying time) is now available. But many artists love acrylics precisely because they dry quickly. That can be an asset.

The paints themselves are available in startling variety: There are regular acrylics and matte, fluid, or metallic acrylics. You can build a three-dimensional surface by mixing gels with the paints, you can paint on a surface built up with acrylic molding paste, or you can mix the paints with gloss or matte mediums. In other words, if you haven't looked at acrylics for a while, now might be the time.

Some artists have switched from oils to acrylics for ecological or health reasons, as did Sheba Sharrow, and some have never painted with anything other than acrylics. The paints certainly are versatile. Harrison Storms mixes sand with some of his colors; he sometimes gouges the painted surface or even grinds it. Acrylics let you do this.

Acrylics serve as a link to oil painting, since you can paint with them much as you would with oils, but they also offer new ways to work. You might even discover some innovations yourself!

Use acrylics for their unique characteristics, and make the most of those characteristics. If you are an explorer, or would like to be, or if you're a little impatient, or if you just want to forget about rules for a while, acrylics can provide you with the perfect means of expression.

## Oils

When through an odd sequence of events I found myself staying on a remote Scottish island, the locals were very curious as to why I was there. "She's searching for her r-r-r-r-roots," one finally (and inaccurately) explained to his friends. Well, oil paints give artists a chance to find their roots.

One artist gives the perfect oil paint description when he recalls the "kitchen pleasures" of working with them. The cozy snick-snick sound when you mix colors with a springy palette knife, the stirring, the pouring; oil paints can be a very satisfying material with which to work. "They're ideal—they allow for you to get in and out of trouble at will," the painter continues. It's true. You can scrape and work back into the painting. Oil paints dry slowly, though some colors dry faster than others.

As with acrylics, oil paints can be worked thick or thin. And like acrylics, new paints and colors have been developed; you can buy lightfast luminescent oil paints now. And many artists like painting with the big oil sticks that are available. So whether it's because you need their history, their flexibility, or just because it's time to smell the turpentine and hear that snick-snick once again, consider working with oil paints.

## *Printmaking*

### Monotypes

Many artists love to make monotypes. The process can be seen as a bridge between painting and printmaking, and it gives the artist a spontaneity that most printmaking doesn't. Since only one print can be made of each painted or inked image, you are free to change that image the next time you print or free to start all over again.

But why not just paint directly on the paper? The answer lies in the way the paint or ink looks in a pulled image: It has a quality that is impossible to duplicate just with painting. In addition, there is always an element of surprise when you lift the paper from the painted or inked surface, and surprise can be fun.

Some artists also find satisfaction in having their painted or inked image reversed. This too creates a feeling of suspense. All prints are reversed, but a positive factor in this method of printing is your

ability to use whatever colors you want, simultaneously, in any one print. There are no separate printings for you to run.

If these things appeal to you, you'll enjoy making monoprints. Monotype is the simplest form of printmaking, requiring very little equipment. It could be just the process you've been looking for to jumpstart your abiding interest in art.

## Lithography

"Oil and water don't mix." This basic truth is the foundation for the mysterious process called lithography.

There are basically two ways to work in lithography. The first is just like drawing. In fact, you may have seen a Matisse lithograph and thought it was a "simple" line drawing! You draw directly on a limestone slab with a waxy pencil, and when the image is printed, the drawing is reversed. You can make many prints from one drawing.

Another way to work is with tusche, which is more like drawing with ink. You can use the undiluted tusche to draw lines or dilute it to make washes. The marks you make with litho pencil or tusche will print in the ink color you choose. If you want more than one color in your final print, you have to create a different printing surface for each color.

Limestone slabs are expensive, and so are printing presses. But if this printing process appeals to you, you might be able to join a printmaking cooperative or enroll in a lithography class. The satisfying weightiness of the slab and its cool, inviting surface help make lithography a great pleasure. The freshness of the finished print is pleasing, too.

Lithography combines the spontaneity of drawing with the discipline required to make multiple prints. Maybe this combination makes lithography the ideal process for you.

## Woodblock Prints and Linoleum Block Prints

Special equipment, or access to it, is sometimes needed for these printmaking processes too. You need the blocks and carving tools to make these prints, and you need a press if you want to create identical prints. You can make unique prints without a press, however, by using a baren or some other hand-held rubbing tool.

This process is another unforgiving one in that once you have

carved into the wood or linoleum you can't change your mind. All negative areas on the block end up printing (or, rather, not printing) as the color of your paper, and all positive areas print in the ink color. As with lithography, if you want more than one color, you have to create a different printing surface for each color.

This finished print looks fresh, but it never looks spontaneous; part of its beauty is the visual evidence of the labor involved in making the print. It can be a very satisfying look, depending on what you are trying to say. I can't imagine carving a woodblock image of a dream, for instance. The method seems too earthbound for that.

But everyone who looks at a woodblock or linoleum block print shares a history of seeing similar prints in old books, as do you, the artist. That heritage can be an enhancement for both viewer and artist.

Do you like planning things in advance? Do you need to improve your ability to carry out what you plan? Does physical exertion give you a feeling of satisfaction? Does the history of this process appeal to you?

Perhaps you just like the way these prints look, and you think that look is suited to your subject matter. Whatever the reason, try carving woodblocks or linoleum blocks, then enjoy the printing process.

## Etching

When you make etchings, your brain has to do a little flip-flop, because the negative line you etch through the dark acid-resisting ground covering your zinc or copper plate is what prints in your ink color. So not only is your printed image reversed, as with all prints, but you are essentially creating a "negative" of the finished work when you etch.

In addition to mental agility, you need patience while you're making the etching. The drawn (etched) line is very fine, so a complex image takes a lot of work, and that's before you even get around to printing it! The printing process is also exacting, since your goal is to create an edition of identical prints.

It has been a while since I made etchings, but I recall feeling a bit historical as I bent over the zinc plate, etching tool in hand. This connection with our art heritage was a pleasant feeling for me.

So if you want to experience an exercise in concentration and you

enjoy detail work, and if you feel that this way of working suits your art, etching is worth a try.

## Serigraphy

It was in the late sixties that I first saw the serigraphs of Sister Mary Corita, later Corita Kent. They suited their time perfectly, as they were both exuberant and poignant. Her serigraphs combined words, sometimes poetic or philosophical writing, with big splashy areas of color, and they were exciting to see.

This technique is relatively recent. It is basically one of repeated stenciling. You apply the stencil (either adhered film or a brushed-on glue solution) to stretched silk and then print the edition. You can use unlimited colors, but you must create a different stencil for each color. The prints often have a free-wheeling look and can be fascinating.

Serigraphy offers you the opportunity to work bigger and a little looser than either block printing or etching. And since no press is needed, serigraphy is a printmaking process that is possible to do in an ordinary studio.

## *Collage*

### Two-Dimensional Collage

"Collage is more than a technique, it is an attitude," says Doug McClellan. I agree with him completely. In fact, an early awareness of this way of looking at the collage process was one inspiration for this chapter. He goes on to say that collage can be many things. It can be "sampling in new music, it can be a visual metaphor for the passage of time, it is a gate to unconscious processes, and it is perhaps truer to the mosaic way we perceive our reality than your average standard painting of middle-distance reality, suitable for framing."

Collage can be combined with printmaking in the Chine collé process, but collage also works with drawing, painting, and sculpture. Why wouldn't it? If the combination works and you like it, do it.

Collage offers numerous pleasures, and the first is collecting materials. Collecting—any old thing that appeals to you! You'll use everything some day. So many artists have mentioned combing yard

sales and swap meets for potential collage material that I have formed a mental image of a swarm of artists at a sale, duking it out over some tasty art morsel. Luckily, there's enough to go around.

If you collect specific images or objects for your work, as do LaMonte Westmoreland and Jerry Barrish (both work in three-dimensional collage, or assemblage), friends tend to do some of the hunting for you. Old calling cards, postcards, doilies: Whether you use these donated materials or not, it's an opportunity to involve others in your work. And that's good for art.

Doug McClellan feels that collage "has a playful dimension. It is free-form, and it has something to do with the magical." He says that the process is "like catnip," which makes it sound irresistible!

If you could use a little catnip, a little playfulness in your life, or if you just want the pleasure of intuitively accumulating objects and the excitement of combining them in unexpected ways, reexperience the collage process. Recapture the collage attitude.

## *Sculpture*

### Three-Dimensional Collage

Three-dimensional collage is sometimes called assemblage, or even junk sculpture, depending on its "ingredients." All of the philosophical elements of two-dimensional collage are still present, but you are now working with objects that take up physical space. Real objects are attached to other real objects. Sometimes they obscure one another, and sometimes they illuminate each other.

Perhaps because we are physical beings, we see these works in a personal way; we look at them in relation to ourselves. We gauge them against our own experience, whether physical or emotional. It's hard to ignore three-dimensional sculpture. Do you like to make things? Are you a problem solver? Do you find significance and emotion in common things? Do you take pleasure in combining ordinary materials to fashion an object that has never existed before? Do you delight in creating an imaginary world, a separate reality?

Three-dimensional collage combines the poetry of the collage attitude with the pleasures of the physical world. It may be an ideal means of expression for you.

*Savarin,* **Jerry Ross Barrish,** assemblage/found objects, 10 $3/4$" × 18"
× 5". Photo by Mel Schockner.

## Two Approaches

Three-dimensional collage is an example of what I call a "building up" type of sculpture. Other examples of this approach to sculpture are wax modeling and clay modeling.

A different approach is what I call the "taking away" method of sculpting. Wood carving and stone carving are examples of this approach. I never really thought much about the differences between these two approaches when I was younger; to me, sculpture was sculpture, and I didn't know how to make it.

But the first year I was in college, something unforeseen happened. After two weeks, a few of us were transferred out of the art fundamentals course into an upper division sculpture class. I adored art fundamentals. However, this was really presented as "an offer we couldn't refuse," so off we went.

But why sculpture? I puzzled over this all year. I thought there must be some plan, some mysterious logic behind the switch. Of course I now understand the choice perfectly. There was room in the sculpture class for more students!

This transfer had three positive results, not all of them immediately apparent to me. The first was a combined benefit: I got to take the last class the sculptor Albert Stewart taught. That was my first semester in college, and the course was in sculptural anatomy. That was the rest of the benefit, because this course indirectly enhanced all my later art, even though that art has not dealt with the figure.

Occurring when it did, on the eve of the general student unrest of the sixties, and considering the impact of that unrest on later arts curriculum at many schools, this may have been the last sculptural anatomy course taught anywhere in the United States for twenty-five years! Even at the time it seemed anachronistic. As I remember it, we stood in a darkened studio, each slowly building up a human torso with bits of modeling clay. And when I say "slowly," I mean muscle by muscle. Albert Stewart seemed to teach by osmosis, which I remember being defined as "diffusion through a semipermeable membrane." My problem was that I wasn't semipermeable, I was dense, or so I felt.

I also thought, "He doesn't like me!" which matters when you're eighteen. Again, I now see things more clearly: How you feel about teachers and how they feel about you matters very little as you get

older and smarter. What matters is that you learn what they have to teach.

But I had gone from being a star (for two weeks) to being a Renaissance drone. My little clay torso wasn't awful; Albert Stewart wouldn't let it be awful, because he made you do each muscle over until you got it right. But my sculpture didn't shine.

We worked on the one torso all semester, nine hours a week. As the final hours (and the critique) approached, I imagined that we would prepare to cast our finished torsos—in bronze, at least. Or maybe that would be the next semester's task.

"All right, now tear them down," Albert Stewart said. "Put the clay back into the bin." We stared at him, uncomprehending. "Go ahead," he said. "That clay is valuable, don't forget." Not only didn't we cast the torsos, we didn't even get to keep them! I couldn't believe it. Never had one of my precious creations been treated so cavalierly.

So the second thing I inadvertently learned was humility. He was right; the clay was valuable. Good modeling clay doesn't grow on trees, you know! And I still had the benefit of the process, even if I didn't have a finished product. Of course I didn't realize this right away. Indignation prevailed for a while. And when I tried to tell people what I had been doing in art all semester, I could truly say, "Well—you had to be there."

A similar switch occurred my first year in a graduate program. The switches didn't come about because I was such a prodigy, by the way. It was more a case of me looking as if I knew more than I really did. But the third result of skipping the fundamentals was that, in the end, I had to teach many of them to myself. Now, though, I think learning some things for yourself, even if it is through desperation, can be the most vivid way to learn.

Albert Stewart retired after that semester, so we had a different sculpture teacher second semester. I leapt from clay modeling into stone carving. It was just me and 250 pounds of alabaster. The heavy iron mallet I used soon helped me develop one buff muscle in my right forearm.

So there we all were, chip, chip, chipping away for another nine hours a week, and I came to look back on the previous semester's tedium with nostalgia. That's when I started to develop the "two approaches" theory, and the parallel theory that each might be best

suited to a different personality type. I toyed with the idea that neither personality type was mine. I suppose the thought of these two types was the genesis of the basic logic behind this chapter, though I didn't take the idea any further at that time.

But I realized finally that I was more of a "building up" person than a "taking away" one. Unfortunately, I never got another chance to try more "building up" media; all of my subsequent sculpture experiences were in "taking away." One of the things I look forward to doing in the next few years is reexploring "my" kind of sculpture!

These sculpture experiences didn't scar me for life, but they did give me an appreciation of struggle, of the strength needed to continue to work even when you're not very good at what you're doing. There's always something you can learn. Before this, things had always come pretty easily for me in art. But after this period in my education, I tried to bring some of that feeling of struggle to all my work, even to those things I was "good at." I learned to fight facility, or at least to be suspicious of it.

What follows is an overview of some basic sculpture media. As with the earlier section on two-dimensional media, each kind of sculpture is presented more in terms of an artist's personality than with the material's technical possibilities.

## Wood Carving

The expression "don't go against the grain" was obviously coined by someone who worked with wood. In one sculpture class, although I still clung to some of the youthful confidence that told me, "You can do anything you want," I remember being impressed when a professor described the futility of fighting a material's inherent properties. A vivid example he gave was wood: What would be the point, he asked, in deciding to carve a perfect sphere from a chunk of wood? Even if you could do it, it wouldn't look right. "Don't fight the material; take advantage of it," was his advice. I found this advice to hold true with every art material I used.

When you carve wood, not only do you "go with the grain," you glory in it. If you're going to end up saying, "Oh no, this still looks like *wood*!" when you've finished, switch materials. It's *supposed* to look like wood.

But when you carve wood, you have to be ready for surprises.

Wood can split or crack, though this is less likely to happen if it has been properly aged and seasoned. Wood can also have hidden inner defects such as soft or hard spots.

If you can tolerate such surprise, which may come after a lot of work has already gone into a piece, if you are flexible enough to "go with the grain," if you love both the basic material and the physical exertion necessary to wield the chisels, saws, drills, and rasps you'll use, you will be rewarded for your efforts.

And wood carving is a slow process, so you'll have lots of time to think as you work. Can you wait for results? In addition, every bit of wood that you remove is gone for good; you can't reconsider and glue the chips back on. That's why wood carving is a "taking away" process. Can you work that way?

If so, there are many woods suitable for carving, so you will be able to choose from different colors, hardnesses, and so on. Slow down! The pleasure of wood carving awaits you.

## Stone Carving

Stone carving isn't as bad as I may have made it sound. You already know how beautiful the finished sculptures can be; you may be a person who enjoys the carving process, too.

Stones suitable for carving come in different colors, degrees of hardness, and textures. Some stones can be polished to a high gloss, while sculptures made from more porous stones have a different look when finished. Either kind of stone can be finished with a textured pattern, if you want. So when you work with stone you have many options.

Although hidden flaws can occur in stones, they are less common in "select grade" stones. In addition to this limited insurance, when you carve stone, you have greater flexibility than when you work with wood; you can carve "against the grain" with stone.

As you know from having seen figures carved in marble that look as close to living flesh as you can imagine, stone can be carved into sinuous forms. Still, it is stone: It's hard to imagine a successful stone carving of a snowflake, for example, which is light, or of waves, which move. The form you choose to carve needs to suit both the material's general properties and your individual stone's peculiar properties—hardness, veining, and so on.

As with wood carving, stone carving requires a capacity for

patience and for the physical exertion necessary to get the job done. You should enjoy the process, not just endure it. As with all art, the stone carver makes one decision after another, but he or she can't reconsider once part of the stone has been chiseled away, "taken away." When you work with stone, you need to be intuitive enough to see what's in the stone and flexible enough to alter your plans while working, if necessary.

But if you're interested in attaining a form of immortality, I can promise you that your work will still be around long after you've gone!

## Wax Modeling and Clay Modeling

Wax modeling and clay modeling are "building up" approaches to sculpture. If you are using wax or an oil-based modeling clay, you start with an armature of some sort and slowly add to it, creating the form as you go. If you want to have a bronze cast made from the finished piece, you will probably take it to a foundry, and they'll make one there.

You can also sculpt with wet clay, sometimes called potter's clay, but if you want to fire your finished piece, you need either to make the piece hollow or thin enough (as in a panel or relief sculpture) so that it won't crack in the kiln. If you fire your piece, you can glaze it if you want. Virginia Cartwright usually combines different colors of clay instead of using glazes.

Any of these methods enables you to work at your own pace. You can work fast or slow, depending on what suits you best. You will need to keep a surface of potter's clay damp the whole time, though, if you are a slow worker.

The "building up" approach lets you change your mind as you work, since you can add to or subtract from your sculpture at any point. This gives you flexibility while you are working rather than requiring it from you, as does the "taking away" approach. Waxes and clays are materials that you touch as you work, so tactile pleasure is an added benefit of working with them. They are basic, earthy materials. In addition, they take up less room than do wood and stone, and the process makes much less noise and mess than either wood carving or stone carving. Ideally these things wouldn't be factors in choosing a material, but in everyday life they sometimes

are. So either of these "building up" materials might offer you your most realistic chance to work in three dimensions.

It can be very satisfying to create physical objects that take up space, that you can touch, and that others can touch. The "building up" processes of wax modeling and clay modeling give you an opportunity to experience this satisfaction.

## *Other Materials*

With what materials do you really feel like working? If a favorite of yours hasn't been included in this chapter, try thinking about that material in some depth. Think about it in relation to your life and to the way you see the world.

This chapter has simply been an overview of some of the most commonly used art materials and methods. Others are mentioned throughout the book. For instance, Claire Henze creates many of her most memorable photographic images using unconventional methods, all of them well suited to photography, and to her. I see a similarity between the sensibility behind these methods and her writing, too; there's a connection.

Jerry Barrish sees a connection between his filmmaking and his sculpture. He likens the editing process to his work in assemblage. "It's all interrelated," he says.

Sometimes the working artist's thoughtfulness becomes apparent in the way he or she talks about the materials used. For an installation artist, "materials" aren't the traditional ones; Stephanie Rowden remarks that there is always "something about the site that I have to hook onto. There's some kind of poetic, resonant element for me. There's some logic there."

Virginia Cartwright, on the other hand, works with a very basic material, clay. But her feelings about her chosen material are extraordinary: "I want my pieces to look like they have a presence of their own. I'm a potter—I'm tied to the vessel, and I have been since I started. I'm part of a tradition. I see the fingerprints on pots in museums, and they're just like the fingerprints on my own pieces. The vessel is a life shape, like it's full of breath. That's what Marguerite Wildenhain told me—she was my role model." Try describing your favorite materials and work methods to yourself, whether on tape or in a journal. It could be an enriching exercise.

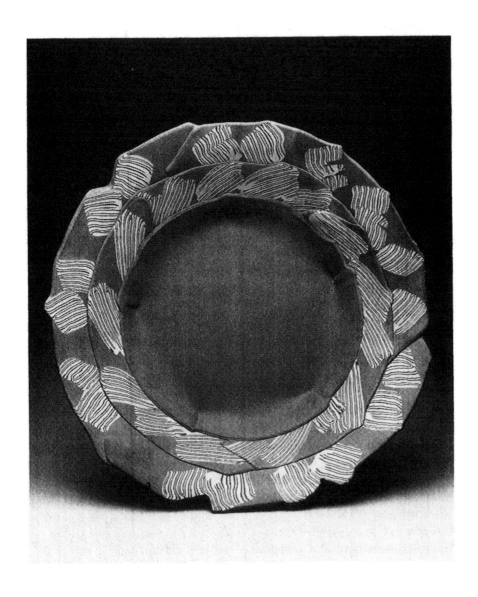

*Folded Bowl,* **Virginia Cartwright,** unglazed clay with inlaid colored clays, 3 ¹/₂″ × 19″ × 19″. Photo by Philip Starrett.

All of these artists spend time thinking about the materials and methods they use to make art, and their ideas are explored more fully elsewhere in the book, as are those of other artists.

The purpose of this chapter has been to encourage you to think about your own materials differently, in more personal terms. You have your personality, and each material or method has its personality, in a way. What you're looking for is a match—a philosophical match, as it was expressed earlier.

As you continue your life in art, continue to contemplate each material with which you choose to work. Explore the history of that material. Learn how it is made. Investigate its technical possibilities. Experiment with it, and take notes. Find a hero or two while you're at it. All these things increase the fun of being an artist.

Most especially, seek out and rejoice in the work of other artists who use that same material or who work in ways similar to yours. Learn from them. These people aren't "the competition"; rather, consider them part of your new art community.

And when you're ready to change the way you work—to change materials—make that change without fear. You can apply the same mental structure to whatever material you use. You'll know when it's time to make a change. One artist describes his experience: "I had begun to be able to predict what I was going to do. And I much prefer to find out what I'm doing at the end of the process rather than know it at the beginning."

Whatever changes you make, the time you give now to thinking about the art materials you use will add to your pleasure in making art and will ultimately make it more likely that you'll continue to make art you truly care about. The time you take to daydream about the poetry of your choice—its autobiographic logic, the varied reasons for it—will be repaid.

That time is never wasted.

# *Toward a More Creative Life*

> **"Awakening with my work finished, I ask myself: 'Whence do we come? What are we? Where are we going?' A thought which has no longer anything to do with the canvas, expressed in words quite apart on the wall which surrounds it. Not a title but a signature."**
>
> **—Paul Gauguin**

WHEN YOUR INTERNAL barriers, whatever they are, threaten to keep you from recognizing yourself as an artist, take time to review: Do you have the artistic structure and community you need? Remember, you have to provide these things for yourself now. And take a look at the way you use time. Examine all the external pressures you face, in fact, and determine if there are ways to alleviate them. Reevaluate both your subject matter and the materials you use.

Review the ten sources of your creative resolve. Which of them might be stronger? Be honest with yourself about your shyness, your doubts, your ambitions, your reaction to rejection. What do you need to do to regain confidence in your vision?

Don't expect anyone to give you either structure, community, momentum, or vision; you have to give them to yourself. You must be the one to make room for art in your life.

Remember, you have to be your own patron. You'll find the more involved you become with your work, the less likely things are to distract you. Your focus will change as your life changes, until guarding your creativity and cherishing your art become top priorities.

In fact, it is likely that your focus will shift toward the possibility of bringing all of the diverse parts of your life together, into the art. Or perhaps it's more a case of letting the art spread out into the rest of your life! Whichever way you look at it, the result will be the

**171**

same: You will then be pursuing the goal of living a life that is both peaceful and whole.

Stephanie Rowden puts it this way: "When I left school, I thought of my life as being very separate from my art, but I think a lot these days about how to live my whole life creatively. I do feel like there are different boundaries between aspects of my life. But I want less to have the experience of turning myself off in situations, of closing down the artist." She goes on to explain, "I want to be able to use some of the tools and skills that come up in making art—that flexibility and fast footwork that you need in order to creatively solve a problem. I want that sense of being able to be very present and awake to experience."

This artist says that her urge toward a more creative life "has ramifications on how I think about making money and on the choices I open myself up to about how I want to live." She realizes that every decision counts when your goal is to live your whole life creatively.

Do you ever remember experiencing a brief period when time telescoped, when things went so well for you in the studio, so perfectly, that you got significant work done that would normally have taken much longer? The elation of a moment like that is mixed with poignance. It's a little like the way you feel when you're aware that you are dreaming, or maybe it's closer to the way you feel when you're aware that you are alive. You know it can't last.

Most of us have experienced this feeling once or twice and thought, "If only I could work like this always . . ." Imagine if that were possible! This is when "that sense of being able to be very present and awake to experience" happens.

These moments are the brief times when there's perfect balance. Creative momentum and vision come together in temporary harmony, or truce, with the pressures of daily life. I think that these balanced moments are glimpses of what it would be like to lead a truly integrated life, one that combines a matter-of-fact awareness of creativity, of vision, with a graceful acceptance—even a reverence—for the external realities of life.

But these moments are gifts. They show us that if we could live our lives this way more often, we could truly be called whole-hearted.

I can't tell you how to turn your life into one made up entirely of

these moments. I don't know how to do it myself. It's probably impossible. After all, the word "balance" doesn't connote a frozen state of perfection; it implies, rather, that a struggle is going on between one force and another. When balance occurs, both sides are temporarily working together. A reconciliation occurs. But the requirements to maintain that balance never stay the same. They change constantly, so personal change will always be required.

And I have a feeling that the struggle to balance inner and outer life is part of what makes life, and art, interesting. That struggle is certainly part of being human. But the experience of balance is a tantalizing one.

I think that an artist has a head start toward the possibility of achieving more frequent reconciliation between inner and outer life, because he or she investigates inner life daily. Who else gets this kind of chance? It's not the deathbed scene some people experience. It's not the last-minute cram before the final.

An artist deals with the hard questions daily, and that takes strength. Rather than perpetual balance, perhaps what should be sought is a way to keep up that strength. Each of you has to do this on your own, but I hope that if this book has done nothing else it has shown that you aren't alone. Remember the varied voices of the artists in this book: They have been saying that there isn't any one way to be an artist. You can invent your own way. Each of the artists in the book has persisted with his or her art in spite of a dizzying assortment of obstacles. The artists have been eager to share their experiences, and they feel a kinship with you, as I hope you do with them.

There are always contemporary fables built up around the death-bed scene mentioned earlier. One fable popular in the last decade ended with the warning: "No one ever lay on his deathbed wishing he'd spent more time at the office." I think that this was an attempt to make people appreciate their children more.

But the moral can also apply to art. Has anyone ever died saying, "I wish I'd spent less time making art"? I doubt it.

I learned this lesson early, as did Claire Henze. She was diagnosed with cancer when her children were very young, two and seven. And, apart from the tremendous shock she felt at this threat to her existence, it was her children and her art that made her feel the "wrongness" of the diagnosis so keenly. Her children were too

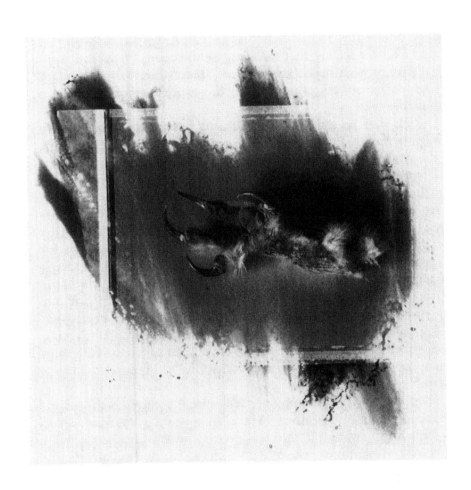

*Relics #3,* **Claire Henze,** manipulated gelatin silver print, 14" X 11".
Photo by Claire Henze.

young to lose their mother. And her art—well, she hadn't started making her real art yet; she'd been waiting, saving it for later.

My reaction to an ominous potential diagnosis was identical, although in my case, the situation was happily resolved in two months. But I knew that my children were too young to lose their mother, and I, too, had been waiting to make my real art. I stopped waiting after that.

Children should all have loving parents to raise them, and artists should all get the chance to make their truest art, but things don't always work out that way. I'm sure that some people die every day, surprised at the unfairness of it all—at the people they are leaving behind, at the art they never got a chance to make. They were saving it for later.

My fellow artist and I had the deathbed preview, the early chance to learn these lessons, and they stuck: A life can change in an instant. No one else will give art to you. Take art for yourself, now, because it's a precious part of you. All of a sudden, it *can* be too late.

We humans are intelligent and sympathetic beings, and while I think we make our most profound changes as a result of personal crises, it is possible for us to make changes simply because the time is right. If a life can take a change for the worse in an instant, then it can take a change for the better, too. That part's fair, at least. And more than time, money, family, friends, the right job, or knowing the right people, what it really takes to be an enduring artist, serious about your work, with room in your life—and heart—for art, is a change in attitude.

If you have been waiting for the ideal time to start making the art you know is inside you, don't wait any longer. Don't learn this important lesson the hard way, when all that's really needed is this change in attitude.

Finding your art again isn't ever easy, whether it's been lost for that one endless day or it's been lost for years. The process is, in fact, an ongoing struggle. But each time you find your art the process gets easier. And the struggle is, after all, the one that best symbolizes your human endeavor to live a real life, fully alive.

# Meet the Artists!

**"I am here on behalf of my own profession, and I trust it is with no intrusive spirit that I now stand before you; but I am anxious that the world should be inclined to look to painters for information on painting."**
*—John Constable*

ALTHOUGH I HAVE known all of them for years, it was a revelation to talk with each of the artists interviewed for this book. No matter how long people have been friends, they rarely sit alone together and talk about one subject in depth the way we were able to. Rereading the interview transcripts provided further illumination; you seldom get the chance to actually see a friend's beautiful words in ordinary conversation. As listeners, often merely waiting for the chance to speak ourselves, there's so much we must miss each day.

One characteristic these artists share is common among artists, I think: It's generosity. These eight people were generous with their memories and opinions. Each made the time to talk to me, to answer follow-up questions, and to round up the photographs that illustrate this book. Why did they do it? At least part of the answer lies in the kinship artists feel for one another. These eight people wanted to help me, but they were also eager to reach out to you, the artist reader.

I asked each of them to give me a résumé. I had thought that the résumés might help me write about them. When I received the résumés I thought—the things friends don't know about one another! Even when artists talk about art together, specific shows, honors, or awards are seldom mentioned. I knew I liked their work, but these artists' accomplishments surprised even me.

Although these eight artists don't all know one another, they all know me; I am friends with each of them. So I decided that rather than merely paraphrase résumés or attempt to write dispassionate profiles, I would introduce each of the artists as a friend. The artists' own words and images, woven as they are throughout this book, have already told you much of what they have to say.

**179**

## *Jerry Ross Barrish*

Photo by Claudia Landsberger.

"The reason that you're doing it is because you have to do it, or you want to do it, or it's fun to do. And if you keep that in mind, then you're squared away."

One rainy night I arrived at the San Francisco airport and caught a shuttle van into the city. I gave the driver an address and settled into the last available seat. Already dressed for dinner, I was to join Jerry Barrish and Nancy Russell at Jerry's office before we all went out. The driver was sure I had the wrong address: "I don't think there are any hotels around there," "Are you sure about this?" and finally,

"Will I even be able to find it?" "It'll be easy," I said. "There's a blinking red neon sign." I suppose he thought I was being ironic.

The "Barrish-Bail" sign is a city landmark of sorts; Jerry has been in business a long time. His office is crammed full of posters, both for his business—my favorite is a psychedelic leftover that reads "Don't Perish In Jail, Call Barrish For Bail"—and for his films. It's surprisingly cozy.

Jerry received his M.F.A. degree from the San Francisco Art Institute. His three independent feature films have been shown at festivals across the United States and at international film festivals in Rotterdam, Uppsala, Antwerp, Florence, Edinburgh, and Berlin, among other places.

Jerry is primarily a sculptor. He creates his assemblages from debris—often plastic—he's collected over the years while walking on the beaches near his Pacifica home. Jerry has shown his sculpture in numerous college galleries and recently had an extended exhibition with another artist at a museum in Arizona. He is represented by several galleries, both in the United States and in Europe. Jerry has been a guest lecturer at the University of California at Berkeley and San Francisco State University and was awarded a lengthy working residency in Germany under the Artists-in-Berlin program.

One of my favorite places in the world to be is standing in Jerry's kitchen (right next to his eagle-topped espresso machine!), watching dogs play in the surf just outside. In addition to being the most passionate sports fan I've ever encountered, Jerry is one of the most naturally sociable people I know. His beautiful shingle-covered house has become a magnet for friends from all over the world. Most of them are artists.

Jerry Barrish works on his art at home, although it's getting crowded. As he puts it, "I could probably be closed down in terms of storage faster than rejection." But a big new studio is in the works. It is to be built in an industrial area of San Francisco. I look forward to seeing that studio completed and to seeing the work that comes out of it.

Jerry and my friend Nancy Russell, partner, painter, and muse, live in Pacifica, near San Francisco. Jerry's two grown children often come from Sweden to visit.

*Virginia Cartwright*

"Let's just say I'm a potter."

When I was in college during the sixties, the old art/craft debate was going strong: What was art and what was craft? Craftspeople inferred that they weren't being taken seriously, and they objected. Artists were defensive, sometimes submissive. Occasionally they were secretly smug.

I like to sort things out, in my own mind at least, and I had finally decided that perhaps the main characteristic of craft was that it could be taught, learned, and mastered. You can learn how to weave a tapestry or to throw a pot, for instance; you can't learn how to

paint a picture or carve a sculpture in the same way. I didn't feel that made crafts inferior, but I did feel they were discernible from art.

As time passed, these neat assumptions were shaken a little. I saw artists who treated their work as craft, and not very good craft, either. I saw craftspeople whose work, I felt, edged toward art. Occasionally I would see craft that existed perfectly in its own world, that created its own world, and I knew it was art. Were these works freaks, accidents?

When I met Virginia I saw first one work, then another, that lived on its own. Virginia's work is no accident, and though she might counter by asking, "What's wrong with craft?" many of her pieces, I feel, are art.

Virginia and I first became friends years ago at a local swim club. She answered my hesitant questions about photographing work and entering shows. She doesn't remember this period at all, but having a well-known, experienced artist take the time to tell me these things, while accepting me completely as a fellow artist, meant a great deal to me.

One of Virginia's most endearing personal qualities is her enthusiasm. She always has something to offer, whether it's news about the most wonderful little restaurant, usually about to close, or bags of fruit and bunches of flowers she's bought at the farmer's market. "I brought home too much. Please take some." She gives things an original twist: I remember at her birthday party a few years ago, we had all gathered at a wonderful little Thai restaurant (about to close), and she'd chosen and wrapped a piece from her collection— for each guest!

Virginia Cartwright was educated in the United States at the Rochester Institute of Technology and studied further in Korea and Japan. While in school, she worked as a lab assistant for such artists as Frans Wildenhain and Robert Arneson. She has been represented by numerous galleries and was recently guest artist at the Garth Clark Gallery in Los Angeles. Many artists admire her for her ability to sell her own work, however. She has served as juror for shows and is especially known for her popular ceramics workshops, which she gives across the country. Her ceramics techniques videos sell nationwide, too.

Virginia's work has been included in numerous art publications, both in books and such magazines as *Ceramics Monthly* and

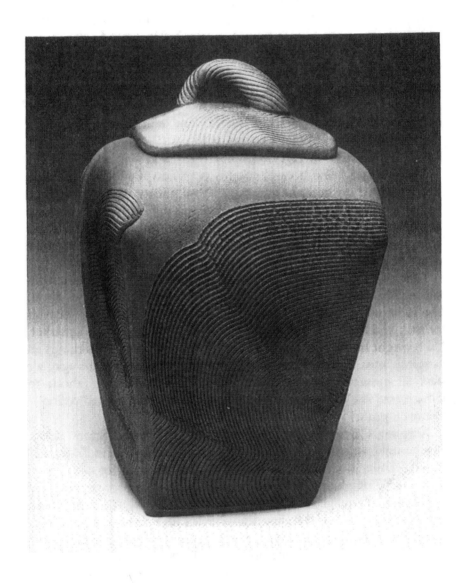

*Lidded Jar,* **Virginia Cartwright,** unglazed clay, 15″ × 9″ × 9″. Photo by Philip Starrett.

*American Craft.* Her work is in many private collections and is also in the permanent collections of the Los Angeles County Museum of Art and the National Museum of American Art at the Smithsonian Institute.

I think the foundation of Virginia's art is the work she has done with different clay-body colors. Her experimentation in this area is noteworthy. Her hand-building method, which she tells me evolved from the unlikely background combination of dressmaking and metalworking, results in timeless vessels: You can almost see the air inside them.

Virginia lives and works at home in Pasadena. Her daughter Erica is a college student at the University of California at Berkeley. Virginia teaches in Los Angeles.

## *Claire Henze*

Photo by Rosemary Henze.

"Art is the one constant path in my life. No matter what else has happened, art has been the bottom line."

Claire Henze's house is up a winding road high in the hills of Pasadena. She lives there with her children, Nico and Anna. The view from her deck is panoramic, yet the house itself, like many hillside homes, has a secluded and private feel to it. Built snug against the hill, most of the living space is in the upper entry-level story, while Claire's studio and darkroom are downstairs.

Occasionally someone lives in just the right place, and that seems to be the case with Claire. Her house fits both her life and art.

I first got to know Claire when our children were in elementary school together. It took a while for us to become friends since we're both so private, but our friendship soon became an integral part of my life. Art is at the heart of that friendship.

Claire Henze was educated in California and has taught at the Art Center College of Design. She has exhibited across the country for years. Recently she was awarded a one-person show at Los Angeles City College and was selected to participate in a small group show at the Armory Center for the Arts in Pasadena. She participated in *A Roof Over My Head,* a collaborative installation concerning housing issues for the disabled. This installation continues to travel around the country.

Claire's work is in major national collections, and she has received recognition from the Maine Photographic Workshops. She has written for the *San Francisco Camerawork Quarterly* and served on the board of directors of the Los Angeles Center for Photographic Studies.

Claire has cancer, and she calls on many of her vital creative attributes in dealing with this illness. She epitomizes grace under pressure for her many friends.

Claire Henze's work has changed over time from straightforward photographic representation to the explorative, painterly darkroom manipulation evident in the *Relics* series. Putting it another way, her work has turned inward during the last few years. The opportunity to track a friend's inner life throughout difficult times is a privilege for which I'm grateful; art has given us that.

It's not possible to categorize Claire's work easily except to say it is always connected to what is going on in her life and in the world. I most admire the energetic spirit with which she approaches each project. Lately she's been learning artist's bookmaking, eager to break into three dimensions, and she's been experimenting with the color photocopy machine. Claire discovers whatever she needs to make her art happen.

## *Douglas McClellan*

Photo by Cheryl Doering.

*"I am serious about the calling of artist. I couldn't stop if I wanted to. I feel very lucky—it is the best of lives."*

Sometimes you get the chance to say "thank you." I got that chance a few years ago when I met Doug McClellan again.

Doug McClellan was one of my teachers and head of the Art Department when I attended Scripps College. He's been head of art departments for twenty-five years; his innate sense of organization, coupled with a genial natural authority, has made this inevitable. I knew him as a teacher, however, and his classes gave me my first understanding of art as improvisation. His assignments felt brand

new and were always challenging. The awareness that there wasn't merely one way to successfully complete them was thrilling for a refugee from the fifties.

But what I wanted to thank him for was what he taught me about teaching. When I agreed to teach part-time at Pasadena City College in the late seventies it was with mixed feelings, but memories of Doug's attitude toward his students made teaching seem like a positive, even creative thing to do. Against all expectations, I loved teaching.

Recognizing the debt I owed him, I thought of Doug McClellan often during the ten years I taught, but as I'm not a person who keeps track of former teachers the possibility of acknowledging this debt was remote. He had long ago moved, and in any case I'd been so quiet in class that I doubted he'd even remember me.

When we met again, almost by chance, he accepted my gratitude kindly and with such practiced ease that I knew I hadn't been the first former student to thank him. In fact I now picture the narrow, tree-lined road that leads to his house as a sort of pilgrimage trail, trod by many.

Doug McClellan is Professor of Art, Emeritus from the University of California at Santa Cruz. He and his wife Marge, also an artist, live in a comfortable house in the hills that surround Soquel, a nearby town. The main part of their house was built in the 1870s and is anchored to a huge redwood stump. This eccentric foundation skews proportions in their living room so subtly that you are startled to find yourself first taller, then shorter than the person next to you, depending upon where you stand! Naturally this doesn't faze Doug a bit, and you soon find yourself wishing that your house was built on a stump too.

In addition to his teaching, Doug McClellan has exhibited his work over the years in repeated one-person shows at the Felix Landau Gallery, at the Pasadena Art Museum, and at a number of colleges and universities. His work has been in group exhibitions at such places as the Library of Congress, the Metropolitan Museum of Art, the San Francisco Museum of Art, and the Sao Paulo Bienale in Brazil.

Doug's early passion for painting has given way to an equally passionate involvement with collage and assemblage. Some of his most recent work is made up of a series of poems, black lettering in

a white room. These poems are to people in his "pantheon," all artists who have affected him in some way: Henri Matisse, Alice Neel, Paul Klee, and Georgia O'Keeffe, among others. Perhaps these poems are Doug's chance to say "thank you."

Doug and Marge, a monotype artist, both work on their art at home. Their grown sons are avid musicians.

## *Stephanie Rowden*

Photo by Joanna Eldredge Morrissey.

"I think times of great change can be very creative—not necessarily in the sense that you produce a lot of work, but you're connected to your own resources at those times."

In 1989 there were two artists' studios at the Ragdale Foundation in Lake Forest, Illinois. Stephanie Rowden was given one and I the other. Artists only come together during mealtimes at colonies, usually at dinner, and visual artists may or may not get to know one another; they're always surrounded by poets and novelists at the dinner table, and they've often marooned in a sea of words. But

visual artists usually laugh at the same things, I've found. Although she is younger than I, Stephanie became a good friend.

Stephanie's is a bright, quiet presence, and people are drawn to her. She later told me, speaking of her work, "I love to listen to stories, and I love to get people to tell me stories." But with Stephanie it's not simply a matter of listening. She has a quality of receptivity that is uncommon. Stephanie seems to be entirely present in each moment, and she's happy if you're there with her. So are you.

Stephanie Rowden was born in Belgium. She grew up and was educated in the United States, receiving her B.A. from Brown University. Stage and lighting design, prop building, painting, and drawing are elements of her participatory installations and sculptures, most of which also include sound. She says, "The process of developing these projects over the last few years has strengthened my enthusiasm for listening as a creative act which uniquely engages the imagination."

I already knew I liked her drawings, but I hadn't seen Stephanie's full-scale installation work until I saw her piece at the Brooklyn Museum in 1990. I was a little nervous; I have to confess that many installations leave me cranky, focused as they are on the artists, no matter what the installations are called. Stephanie's installation was different. It was "turned out." It included the world. The installation irresistibly invited the viewer to be part of it. Museum patrons, dutifully plodding through the exhibits, stopped—enchanted—and stayed. I should have known Stephanie's work would be like that.

Stephanie Rowden's smaller work has been shown in numerous group shows at such spaces as the Richard Anderson Gallery and the Henry Street Settlement, both in New York City. Her larger works have been installed for City Without Walls in New Jersey, for White Columns and Art in General in New York City, for Art in the Anchorage at the Brooklyn Bridge, as well as for the Brooklyn Museum.

Stephanie is the recent recipient of a visual artist fellowship from Artmatters, Inc. and has twice received grants from Artist's Space in New York. In addition, she has been invited to work at the MacDowell Colony in New Hampshire as well as at the Ragdale Foundation.

Stephanie Rowden is the youngest of the artists interviewed for

this book. She has overcome physical obstacles that would have challenged many of us right into the ground, and she has continued to grow. I can't wait to see what she'll do next!

Stephanie lives in Brooklyn with her husband, the composer Andy Kirshner.

## *Sheba Sharrow*

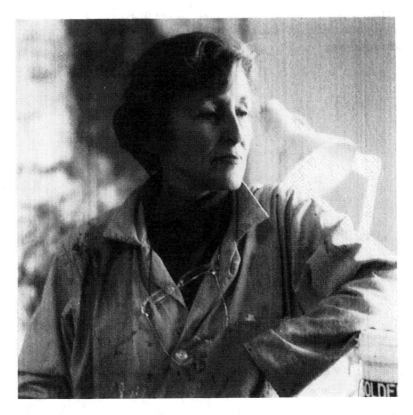

Photo by Lisa Morphew.

"If you can say to yourself, 'Oh, I can live without this,' then I don't think you should pursue it."

Early in 1991 I was a fellow at the Virginia Center for the Creative Arts for a month. Toward the middle of my time there I started to hear, "Did you know Sheba's coming?" and "When's Sheba getting here?" I jealously decided in advance that I wouldn't like her, and then she arrived. I liked her. I liked her paintings, too. The only problem was that we were both working so hard, we didn't get to spend much studio time together. But at dinner and the occasional

hilarious restaurant meal, to which a few of us would flee, we became friends.

Sheba is passionate about what is going on in the world, and she elicits the best from you. You can't be a lazy thinker and be Sheba's friend.

Sheba Sharrow's work is rich, masterful, and poetic. It is primarily based on the human figure; the viewer is drawn into the mystery and what another writer has called the "humanity" of her large paintings. Sheba describes another artist's work: "I walked into these galleries that had Eakins, and it was just like inhaling a breath of air, because here was a painter who was so totally real and so true to himself." I think the artists in Virginia sensed the same qualities in Sheba, and that's why they were so excited she was coming.

Sheba Sharrow inspires loyalty among her artist friends because of the quality of her work and because of her reverence for art. She was educated at the Art Institute of Chicago and received her M.F.A. degree from Temple University. Sheba has had many one-person shows at such galleries as Paula Allen in New York City, at Loyola University in Chicago, and at Tremellen Gallery in Lancaster, Pennsylvania. She has also participated in many group exhibitions, including the recent *Images of Courage and Compassion* show at Millersville University of Pennsylvania.

Sheba Sharrow is in such public collections as Citibank of New York and Cigna Corporation of America. She has been awarded numerous resident fellowships at the Virginia Center for the Creative Arts and has also worked at the Blue Mountain Art Center and at Mishkenot Sha'ananim, in Jerusalem. Retired from teaching, Sheba is a noted lecturer and panel speaker on the arts.

Sheba lives in New Jersey, and she has her studio at home. She has two grown children.

## Harrison Storms

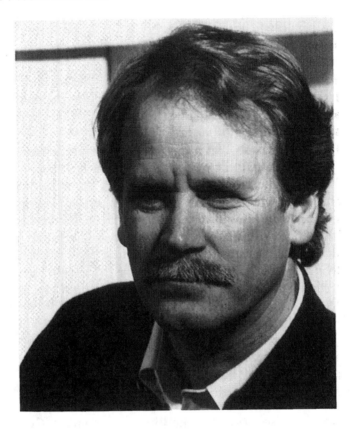

Photo by Andrew J. Caudillo.

"I've never stopped making art, never. This is not a casual commitment."

Harrison Storms and I attended Otis Art Institute in Los Angeles at roughly the same time, and we became friends. We both had red hair, we always made each other laugh, and we loved drawing.

Years later I would hear of him every so often from fellow teachers and wasn't at all surprised that he was continuing to make art. It was as predictable as these things are possible to be. When we finally renewed our friendship it was through the Lizardi/Harp Gallery in Pasadena, which represented us both. Harrison and I carried on a

years-long extended conversation then, one that stretched from opening to party to opening. Now we have to make more of an effort to talk with one another, but it's always worthwhile.

Harrison Storms has taught at a number of colleges, and he loves teaching. He must be a wonderful teacher; he speaks eloquently of getting his students to think about things differently. When he teaches drawing, for instance, he makes it an "exercise in concentration," which is what drawing really is.

Italian fresco painting is a primary influence on the physical appearance—the surface—of Harrison's work. There's an interesting contradiction in his art: Harrison's painting method is very workmanlike, involving troweling, gouging, and grinding, yet the finished pieces are sublime. They usually reveal exquisitely rendered anatomical fragments. As he puts it, "I keep working on a piece until I find the relationships I want."

In addition to receiving his M.F.A. degree from Otis Art Institute, Harrison was invited to study at the Ruskin School of Drawing at Oxford University. He learned to make his own pastels there, an experience that fills me with envy, and his work was exhibited at the Ashmolean Museum. Harrison has had other one-person shows at the Lizardi/Harp Gallery, at the Palos Verdes Art Center, and at Harbor College.

Harrison's apartment and studio are near each other and are not far from the Pacific Ocean, although I've never heard him talk about the beach. As he puts it, he responds "to commonplace things," so Harrison speaks more about peeling pastel stucco, earthquakes, and riots. The usual L.A. chat. As he wants his work to reflect the phenomenon of change, he's living in the right place.

## *LaMonte Westmoreland*

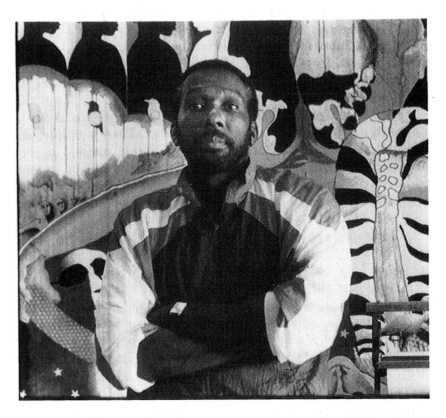

Photo by Judith Gordon.

"I never really know when I first start out what I'm looking for, but once I find it . . . I see an image that I can use and go back and make something out of it."

LaMonte Westmoreland's art-filled house is tucked away near the top of a canyon road in Pasadena. A fence separates his back yard from the Angeles National Forest, and he tells me he and his wife often sit outside in the evening and watch the wildlife on the opposite hill. And it can get pretty wild: Shortly before I interviewed

LaMonte, two nearby hikers had to be airlifted to safety after being forced to scrabble up a crumbling bluff by a mountain lion!

Inside the house, things are a lot more civilized. Striking African sculpture is displayed, as are the many two-dimensional pieces—especially drawings—that LaMonte and his wife have collected. A simple walk down a hallway turns into a treasure hunt as you recognize images and names or are entranced by unfamiliar work. The whole house is like that.

LaMonte Westmoreland grew up in Wisconsin, came to California to attend college, and has lived in California ever since. He received both his M.A. and M.F.A. degrees from California State University, Los Angeles. He taught the whole time he was in school, as he still does. I think his high school students, especially, have the most unbelievable luck to have LaMonte as teacher.

LaMonte and his wife Martina, a school principal, have two grown sons. One is a producer for public service television at the University of Wisconsin and the other has started his career in theater management.

I first met LaMonte at the Lizardi/Harp Gallery in Pasadena. In addition to his one-person shows at that gallery, LaMonte has had numerous shows at the Tanner Gallery in Los Angeles. His work has also been exhibited at Los Angeles City College and at California State University, Los Angeles. In addition, LaMonte was recently awarded a Rhode Island School of Design Fellowship.

LaMonte has been included in recent group exhibitions at the Harcourts Contemporary Art Gallery in San Francisco, at Purdue University, and at the University of Wisconsin. Much of his work is assemblage. It is serious, yet it often contains elements of humor.

One thing that LaMonte Westmoreland and I share is a high regard for Charles White, an important American—and African American—artist. Charles White taught at Otis Art Institute when I was there. He effectively imparted his love of realism, of drawing, and of charcoal drawing, in particular. LaMonte knew Charles White through the African American art community.

I got to know LaMonte very slowly. I always admired his work but rarely got the chance to say so. He would appear, then disappear from openings silently, like a wizard. (He now points out that we have that in common, too!) But LaMonte's passion for art, his belief

in art as a viable way of life, and his loyalty to other artists gradually became obvious to me.

LaMonte is an inspiration, a quiet, supportive presence fellow artists can rely on.

## *Sally Warner*

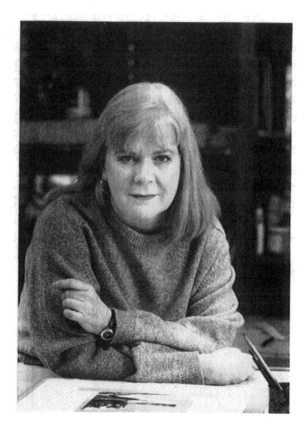

Photo by Claire Henze.

I grew up in Connecticut, then I moved to California with my family. I've lived in California ever since. I attended Scripps College and received my M.F.A. degree from Otis Art Institute.

I taught art to children during high school and college and later taught art to teachers for ten years at Pasadena City College. I then wrote and illustrated my first book, *Encouraging the Artist in Your Child,* and a second book, *Encouraging the Artist in Yourself.* I wanted these books to help make art accessible to more people. I sometimes write for a children's magazine and am working on a book that will unite my writing and drawing.

My art is almost entirely drawing. I work primarily with charcoal—powder, vine, and pencil. In the last few years much of my work has been landscape, but I am also interested in drawing its separate elements, plants, trees, clouds, and—lately—water.

I have had numerous shows in galleries and colleges and am currently represented by the Eye International Group in New York and Art Source L.A. in Santa Monica. I have been invited to work at Villa Montalvo, the Ragdale Foundation, and the Virginia Center for the Creative Arts. I was recently included in the book *The Mystical Now: Art and the Sacred* by the English writer and critic Wendy Beckett.

I have lived and worked at home in Pasadena for fourteen years and, before that, in Los Angeles. My house is a small craftsman bungalow. There's a redwood tree in the front yard, and my studio is the converted one-car garage in back. My son Alex is a film student at Art Center College of Design, and my son Andrew, a high-school student, is a dancer.

# APPENDIX ONE
# *Exhibition and Colony Opportunities*

**E**VEN THOUGH LIFELONG artists have learned to focus on the process of making art, sooner or later external attention will turn to what is being made. Once you are out of school it's up to you, the artist, to determine how you want to handle this attention.

You might decide not to show your work at all. Yes, you can choose to be the Emily Dickinson of the visual arts! Your work will still exist, and if you take good care of it, and if your heirs do too, maybe some day it will be appreciated by others. Or maybe not, but at least you got to make the art. That puts you on the side of the creators, and they're the good guys.

But it's natural for many artists to want to show their art in some way—the phrase "show their true colors" comes to mind as I write. Although many nonartists characterize this urge as either attention-grabbing or an attempt to cash in on a good thing, I think the impulse is founded more in the previously discussed yearning for structure and community.

In our culture, art is seldom solely for religious ritual, so we tend to have a "What's next?" attitude about the finished work. We made it, now what do we do with it? It can seem as if the work's purpose has yet to be served. The art is commonly seen as a thing, a commodity, so "what's next" is often an attempt to give the work public value, and the structure of the art establishment is already in place to do this.

A sense of community is an important urge too. Making art requires a high degree of isolation, and obviously artists get lonely. It's natural for them to want to associate with other artists, to "belong." Other artists have the same priorities.

Another sense of community is satisfied through contact with the people peripherally connected to the arts. You are saying, "I am part of this world; this is who I am, and this is what I do," to a receptive audience, in a fairly safe environment. That is, you won't be viewed as a total weirdo or rounded up by the thought police. All you'll have to face is a reaction. It could be rejection, but maybe they'll like your work.

So even if you're not driven by a need for attention and acclaim, you might well choose to let the world know what you're doing. And if you see yourself as a "career" artist, then you definitely will establish contact with that peripheral arts community.

To reduce it to a manageable overview, I will write briefly about several different ways that you, the artist, can gain exposure for your work in that community. Although the ways are roughly listed by degrees of difficulty in gaining acceptance to them, you can (and will) be shot down by any of them at virtually any point in your creative life. You'll never be completely "safe" from rejection.

## Juried Shows

Your first attempts to get your work seen will probably be through entering juried shows. These are advertised. Submissions are solicited, and with good reason. You pay a fee to be considered for most shows. A juror usually selects work for the show from slides, and if a piece of yours is selected, you send it to the show.

There are a number of pitfalls to juried shows, although such shows can serve a purpose for the artist. One pitfall is that anyone can organize a juried show. In fact, I've heard that such shows are appearing as schemes in get-rich-quick books. It's not the artist who's getting rich quick, by the way.

Do you know anything about the gallery? *Is* there a gallery? What about the juror? Do you even know that the show is eventually going to be hung? If a person can get 250 artists to each mail in $15, some money has been made.

Be selective. Enter shows that have some history. Research the juror if you can. Ask if the work will be insured while on exhibit and if the space will be guarded.

What good can a juried show do for an artist? At first it might just serve as an added line to your résumé, but that line could get a gallery director's attention. Sometimes an artist can gain an influential juror's attention, and occasionally professional connections are made with people who come to see the show.

The least tangible purpose such a show serves is to generate some excitement and hope in your life during the period of anticipation—usually two months—between submission and notification. That period can be fun.

## Galleries

You may decide that you want to approach galleries for possible representation. Galleries should never ask a fee for looking at work, but they will probably take a long time getting back to you. Expect this. (By the way, always encourage people to keep your slides for as long as they'd like, but always enclose an SASE. Make it easy for them to reply. These people are on budgets, too.)

One thing that will be hard to keep in mind, given the ratio of artists to galleries, is that it's not just a question of a gallery choosing you; you're choosing the gallery as well. It will be hard to maintain this attitude, but be selective with galleries.

Artists have different ways of judging galleries. When I started out my approach was highly unscientific. Using *Art in America*'s "Annual Guide to Museums, Galleries, and Artists," which comes out each summer, I started by selecting cities I'd like to visit. Honestly! I liked the idea of far-away places, since I knew I'd prefer rejection through the mail to rejection in person—which I almost wrote as "personal rejection," giving you some idea of how I sometimes feel about it.

Then I went through the galleries listed in each lucky city, eliminating any that sounded inappropriate ("19th century European and American art") or silly ("colonial furniture, Italian paintings, and contemporary art"). Next, I reviewed the directors' names and artists represented, checking for women. And then if I still liked the feel of the place, I'd send off a packet of slides and related material. Throwing a dart at the magazine works, too.

I had a surprisingly positive response to this idiosyncratic method, but there are other approaches that make more sense. For instance, it's a good idea to see a gallery before submitting anything. One artist says, "What I do is, if I go to another city, I look in on the art. I talk with the people in the galleries. I just get a good feel for the gallery from what they're showing, and the personnel. Personnel is important to me—if you have a bunch of snooty people in there, I don't want to deal with them. When I get back home, I'll send them some slides and stuff. Usually my feelings are right on."

Sometimes it's a valuable experience to visit even an interested gallery incognito. I once decided against working with a gallery when I saw the sloppy way they treated the work. And if you find that you are having trouble communicating with a gallery when they're interested in you, imagine the trouble you'll have when they owe you money!

Another artist always follows up her preliminary visit and slide submission with a phone call; she tells the gallery director in advance that she'll be doing this. You can be sure that her slides get looked at early. She establishes a personal connection that sometimes leads to rapport. Of course, her work is good. That helps!

## College Galleries

Another category of artist involvement is through submission to college galleries. Requests for submissions are often advertised. No fee should be charged for such submissions.

These galleries plan their shows a year or more in advance, and they're interested in seeing a wide variety of work. Therefore, you'll be able to demonstrate the depth of your involvement with your subject matter through your slide sheet. And unlike commercial galleries, academic galleries aren't concerned with selling work, so these shows can provide a good chance for an artist to show unusual work. Again, check that any exhibition will be both insured and guarded.

Juried shows, galleries, and colleges are lucky to have artists send them work to consider. It's what keeps them going. The artist loses sight of this, and that's a pity. However, it's obvious that everything that's submitted can't be accepted. Unfortunately, the artist pays

the emotional price for this fact. If you're going to participate in the process, there's no way around that consequence.

But I wish that every artist could have the experience of jurying a show! It would be both a comfort and a revelation. It's not that the procedure is at all arbitrary—in my experience it's not—but jurying is subjective. It all boils down to one person, the juror, making a series of decisions. (I much prefer this to committee action, by the way. As an artist, my worst experience so far has been with an arts commission in a large American city—let's just call it "San Francisco"—that kept stringing me along throughout eighteen months and three committee changes before it finally decided "no." I'd much rather just have some crank scream it in my ear, but right away.)

So the juror looks at a lot of work, a lot of *good* work, and has to put together a show. This automatically means some submitted work is rejected. Decisions have to be made quickly, intuitively. The juror must consider the size of the exhibition area and sometimes such restrictive issues as theme ("landscape"), materials ("watercolor"), eligibility ("gay artists"), and so on. And then the awards that are available for the selected works often have arcane strings attached; the juror might be asked to give an endowed award to "the best two-dimensional figurative work by a woman living within a five mile radius of the museum," for instance. Well, that's an exaggeration, but just a slight one.

The whole jurying experience is humbling, in a way, but exhilarating. Once you take part in the process, you'll never look at rejection in the same way. You'll never take it as personally again!

Juried shows advertise for submissions in various art publications. The artist sends for a prospectus then is usually instructed to pay an entry fee and submit two or three slides for consideration.

College galleries often advertise for and review artist submissions in planning upcoming exhibitions. If you submit work to a college gallery or to a commercial gallery, you send a labeled slide sheet which holds up to twenty slides, a résumé, other material related to your work—photocopies of reviews or show cards, for instance—and a SASE. I often specify "For return of slides only" on the SASE to reduce postage costs. I sometimes include one large photograph of my work in the packet to engage attention.

Art colonies often advertise for submissions in art publications too.

Most colonies have two application deadlines a year. Each colony requests different things from its applicants, but it is common to be asked to submit slides of recent work, a résumé, and two or three reference letters. An application fee is usually requested as well.

It can be hard to find the time and money to go to art colonies, and it's hard to get into colonies, but most artists find a colony stay an unforgettable experience. It's worth a try.

There are different regional art publications, but one national monthly publication includes current information on juried shows, college shows, museums reviewing portfolios, colonies, and so on:

*ArtCalendar*
P.O. Box 199
Upper Fairmount, MD 21867
(410) 651-9150
(800) 597-5988 (to charge subscription)

The subscription rates are around $32 a year for second class delivery. First class delivery (recommended if you live in the western states to avoid missing submission deadlines) is around $45 a year.

# APPENDIX TWO
# *Art Materials*

IT IS NO longer necessary to feel you're at the mercy of your local art supply store, assuming there even is an art store near you. Many artists order at least some of their supplies through catalogs. Catalogs offer a wider variety of materials than most stores can, they often charge less than stores do, even taking shipping costs into account, and delivery is quick. In addition, some materials that stores only offer in sets, such as pastels or colored pencils, are available in individual colors ("open stock") through catalogs.

The best catalog referrals are through word of mouth. Here are some catalogs I use:

Daniel Smith
PO Box 84268
Seattle, WA 98124-5568
(800) 426-6740 (to order)
(800) 238-4065 (fax)
(800) 426-7923 (customer service)

The Daniel Smith catalog is especially good for drawing, painting, and printmaking supplies. They have a wide assortment of framing supplies, too. They offer a wonderful paper selection, and orders arrive very promptly.

Light Impressions
439 Monroe Avenue
PO Box 940
Rochester, NY 14603-0940

(800) 828-6216 (to order)
(800) 828-9859 (customer service)

Light Impressions carries "archival supplies." Their catalog selections of slide sheets, aluminum and wood frames, interleaving papers, and precut corrugated board, mat board, and foam board are especially helpful to the artist. They have a custom mat-cutting service that is excellent.

University Products
517 Main Street
PO Box 101
Holyoke, MA 01041-0101
(800) 628-1912 (to order)
(800) 762-1165 (customer service)

The University Products catalog carries many of the same materials Light Impressions does, though perhaps it offers greater variety to the artist. Rather than backorder from either catalog, I simply call the other business.

Airfloat Systems, Inc.
PO Box 229
Tupelo, MS 38802
(800) 445-2580 (to order)
(800) 562-4323 (fax)

Airfloat Systems sells lightweight, strong, reusable packaging the artist can use to ship framed or unframed artwork. For framed work, the lined "Print Line" boxes have layers of foam inside. The artist cuts a nest for the art from the perforated central layer of foam. The outer walls of the boxes are lined with a puncture-proof material.

The lined "Print Pad" packets are for unframed work, though I have used them to send matted work. They too are lined with a puncture-proof material. This product is a big improvement over either scrounging for boxes or building plywood crates when you need to ship work.

# Notes

1. Dennis Finnell, "Taking Leave of St. Louis," in *Red Cottage* (Amherst, MA: University of Massachusetts Press, 1991), 12.
2. Molly McQuade, "Richard Ford," *Publishers Weekly*, 18 May 1990, 66.
3. V. S. Pritchett, *A Cab at the Door* (New York: Random House, 1967), 244.
4. Gustave Flaubert, *Sentimental Education*, trans. Anthony Goldsmith (London: J. M. Dent & Sons Ltd. Everyman's Library, 1941), 36.
5. William Wilson, "Still Life With Emotion," *Los Angeles Times*, Wednesday, 28 October 1992, Calendar section.
6. Alfie Kohn, "Reward and Creativity," *Los Angeles Times*, Monday, 4 December 1989, Metro section.
7. Suzi Gablik, *The Reenchantment of Art* (New York: Thames and Hudson, 1991), 26.

# Acknowledgments

First, I thank the artists interviewed for this book. I greatly value the time we spent together. I also thank the other artists who were willing to participate but were never interviewed, due only to time and geography. I thank my family for their support and for the lessons they have taught me.

I thank poet Dennis Finnell for letting me use his words to open the book. I thank Kit Davis, Claire Henze, and T. Carole Eden for their comments on the working manuscript, and I thank T. Carole Eden once more for her work on the transcripts and the manuscript.

Next, I thank the Virginia Center for the Creative Arts for giving me time to create the proposal for this book. In addition, I thank the Authors Guild for its guidance.

I thank Ralph Mayer's classic *The Artist's Handbook of Materials and Techniques* (The Viking Press) for refreshing my memory about various ways to work, and I thank Louis Kronenberger's *Atlantic's Brief Life: A Biographical Companion to the Arts* (Atlantic Monthly Press) for reminding me of the varied lives artists have led.

Finally, I thank Amy Teschner and Chicago Review Press for both their imagination and their confidence in this project.